Hello! I would like to Thank you! for your support!

These are all digitally drawn by me.

Please do not sell, redistribute, edit, publish, share or give away any of the images from this book. These are intended only for the purchaser.

Personal usage only. Cannot be used for commercial purposes or by anyone other than the purchaser.

You are encouraged to share your colored results on social media. I can be found here :

f Digital Creations by Shawn Bobar

◉ @DigiCreationsbyShawnBobar

BuggaEyes Collection:
Names I've chosen, however, you can color them as girls or boys!

Bayou the Bird
Beatrice (Bea) Bee
Bettie the Butterfly
Carlton the Cat
Chester the Chipmunk
Clyde the Cow
Collin the Crab
Darcy the Dachshund Dog
Deidra the Dragonfly
Delaney the Dog
Duncan the Dragon
Esteban the Elephant
Eunice the Unicorn
Freddie the Frog
Gerry the Giraffe
Gladys the Goldfish
Hattie the Hippo
Jensen the Jellyfish
Katie the Caterpillar
Leonard the Lion
Lillian the Llama
Louisa the Ladybug

BuggaEyes Collection:
Names continued

McKinley the Monkey
Motley the Moose
Murphy the Mole
Oakley the Owl
Olive the Octopus
Percy the Panda
Polly the Pig
Ralph the Manbug Ladybug
Rowdy the Raccoon
Shelley the Sheep
Starla the Seahorse
Tilly the Turtle
Ulysses the Dog

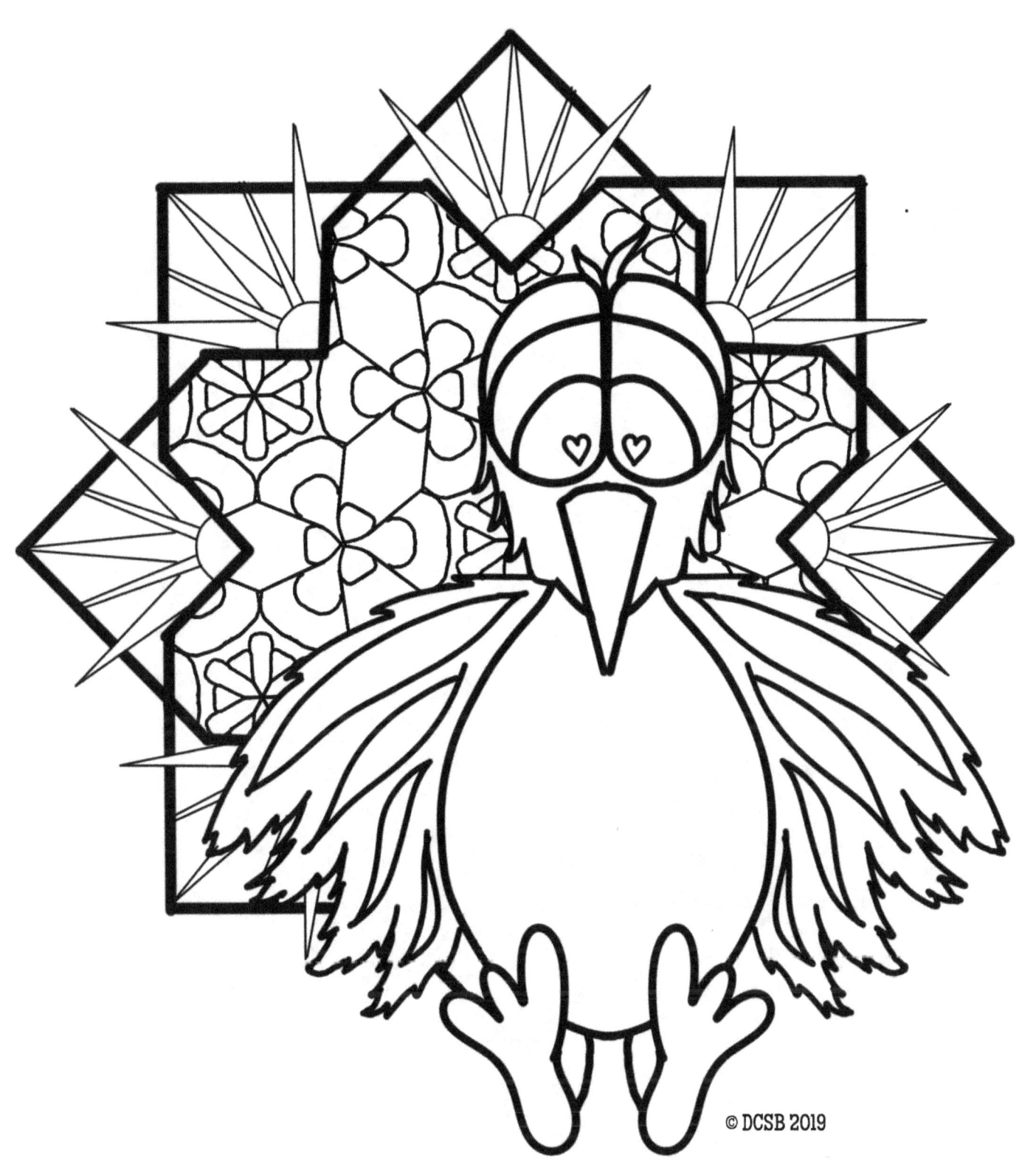

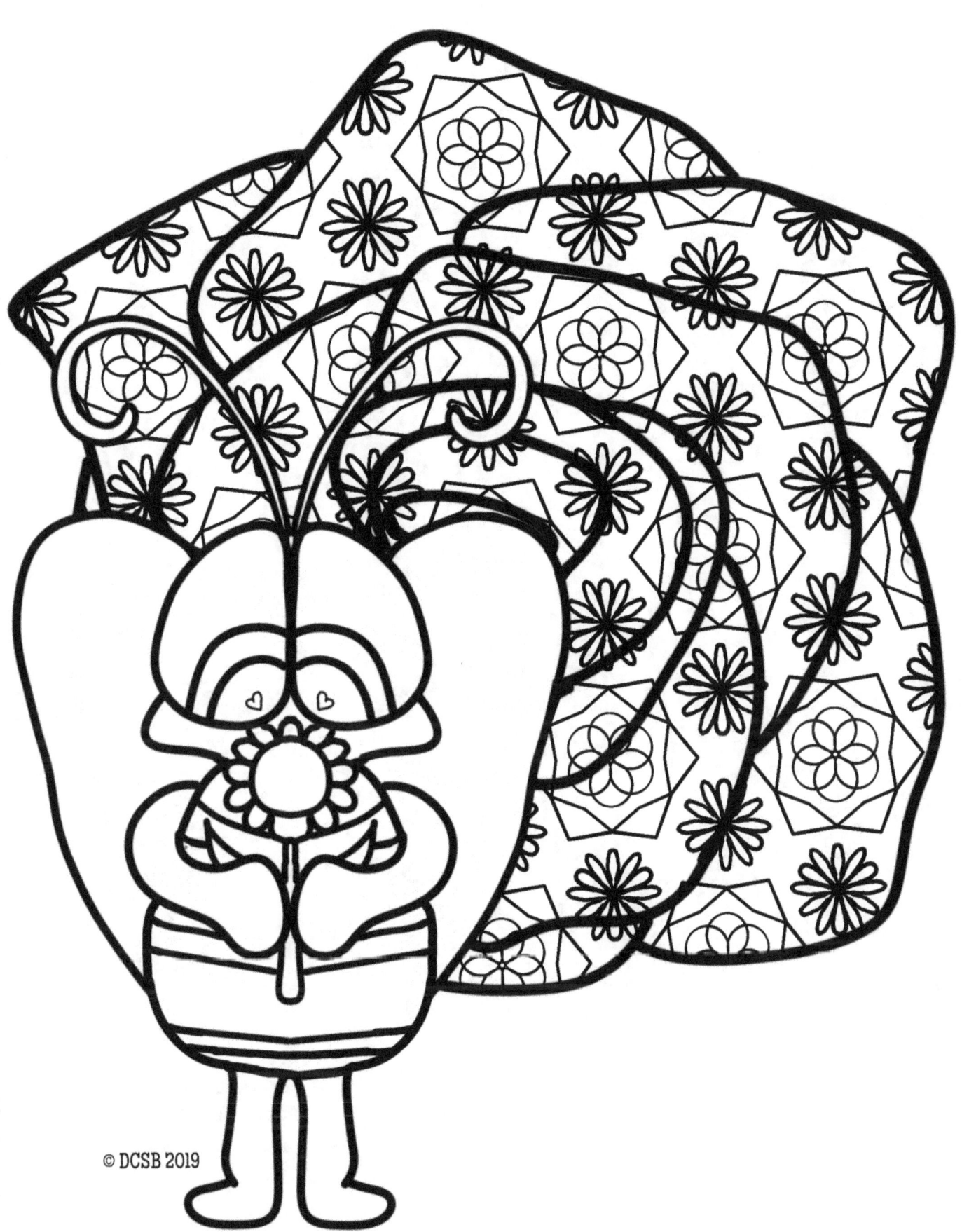

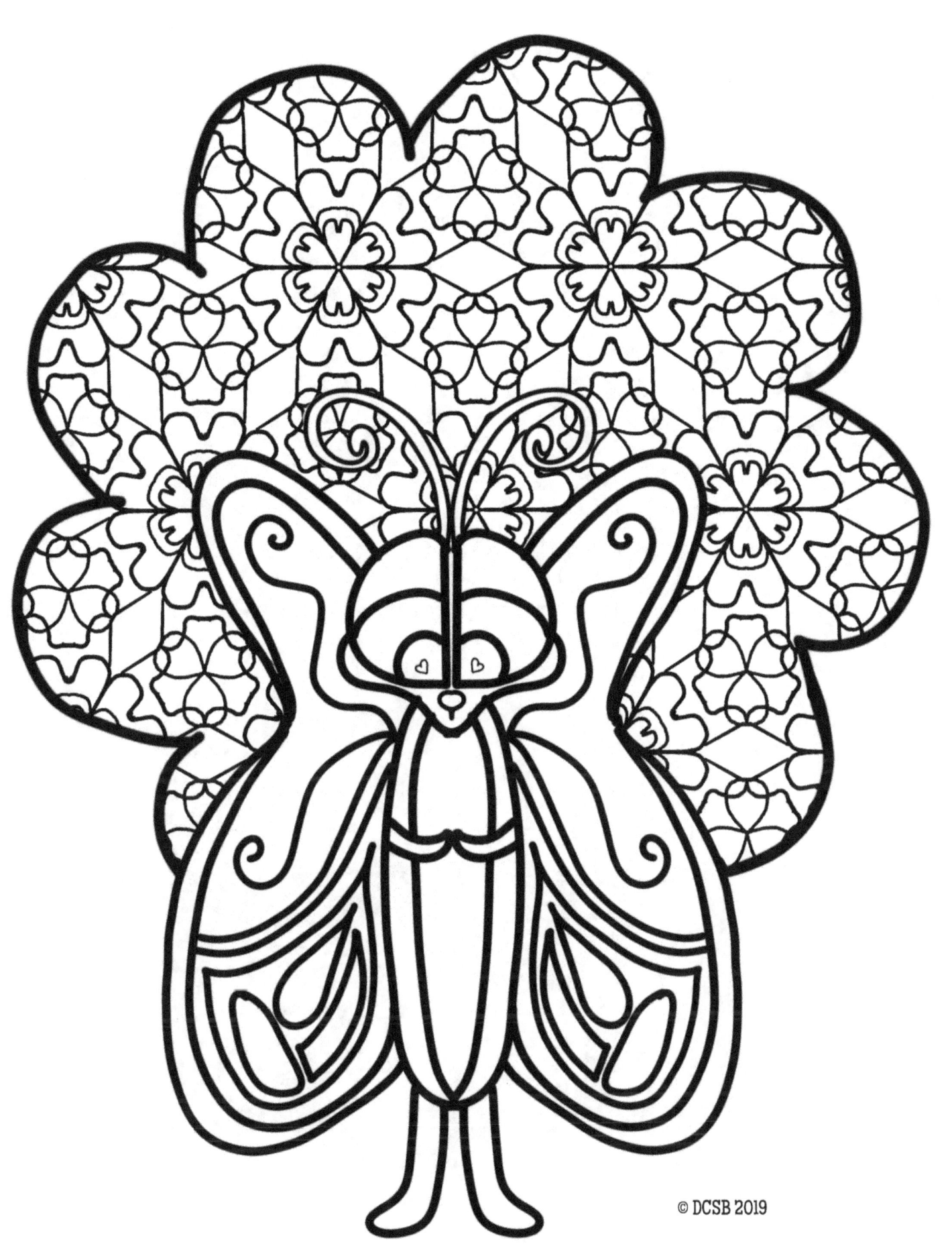

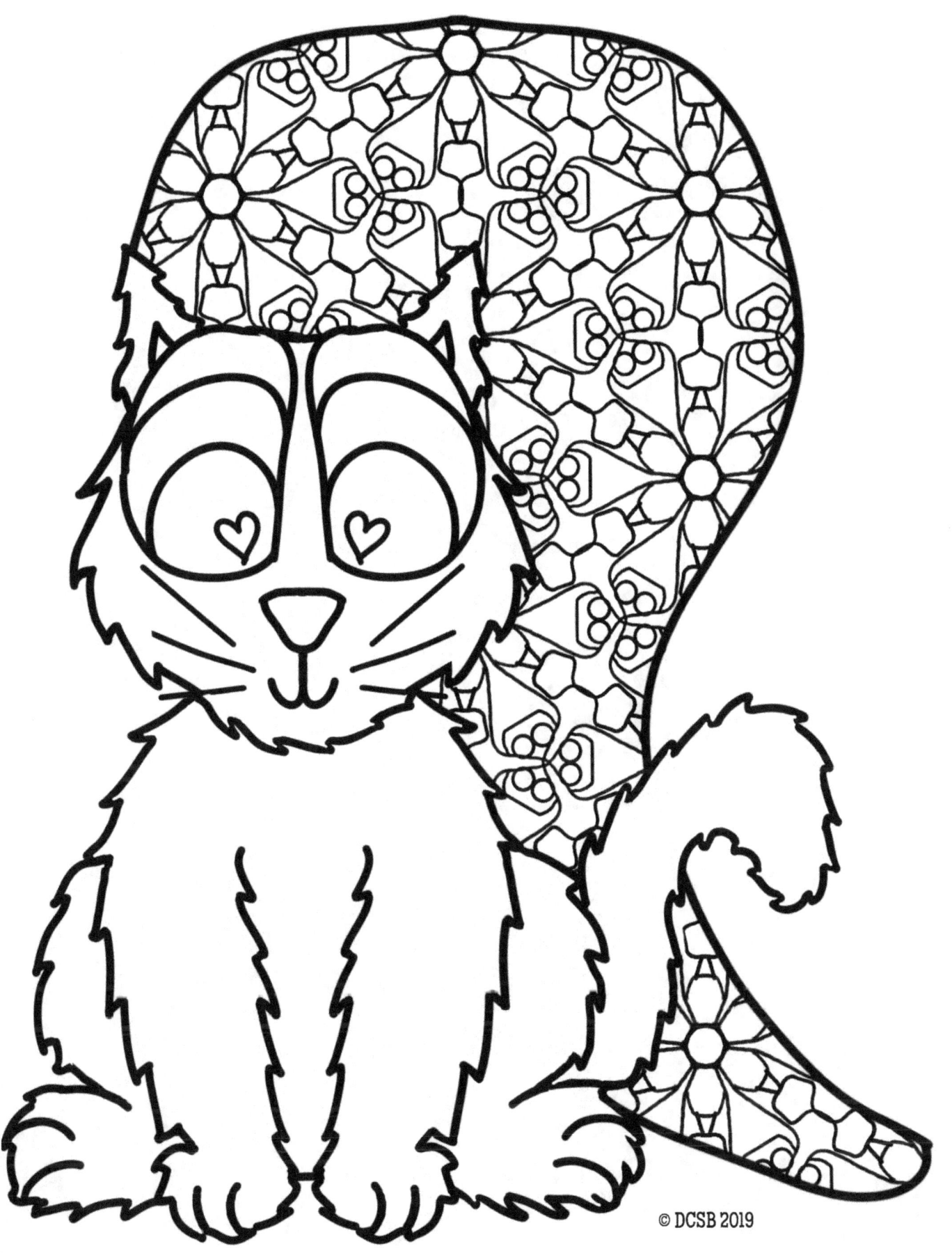

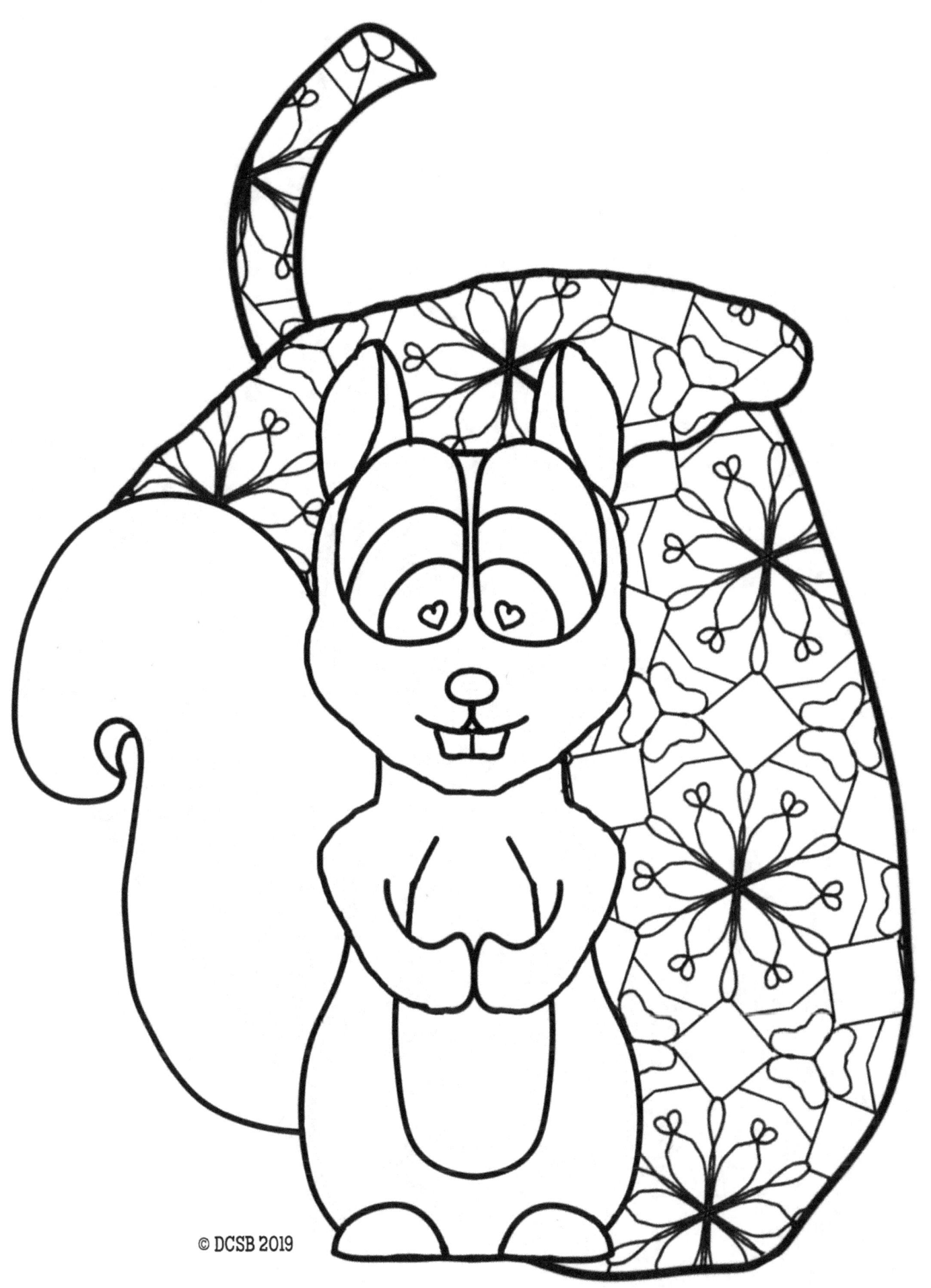

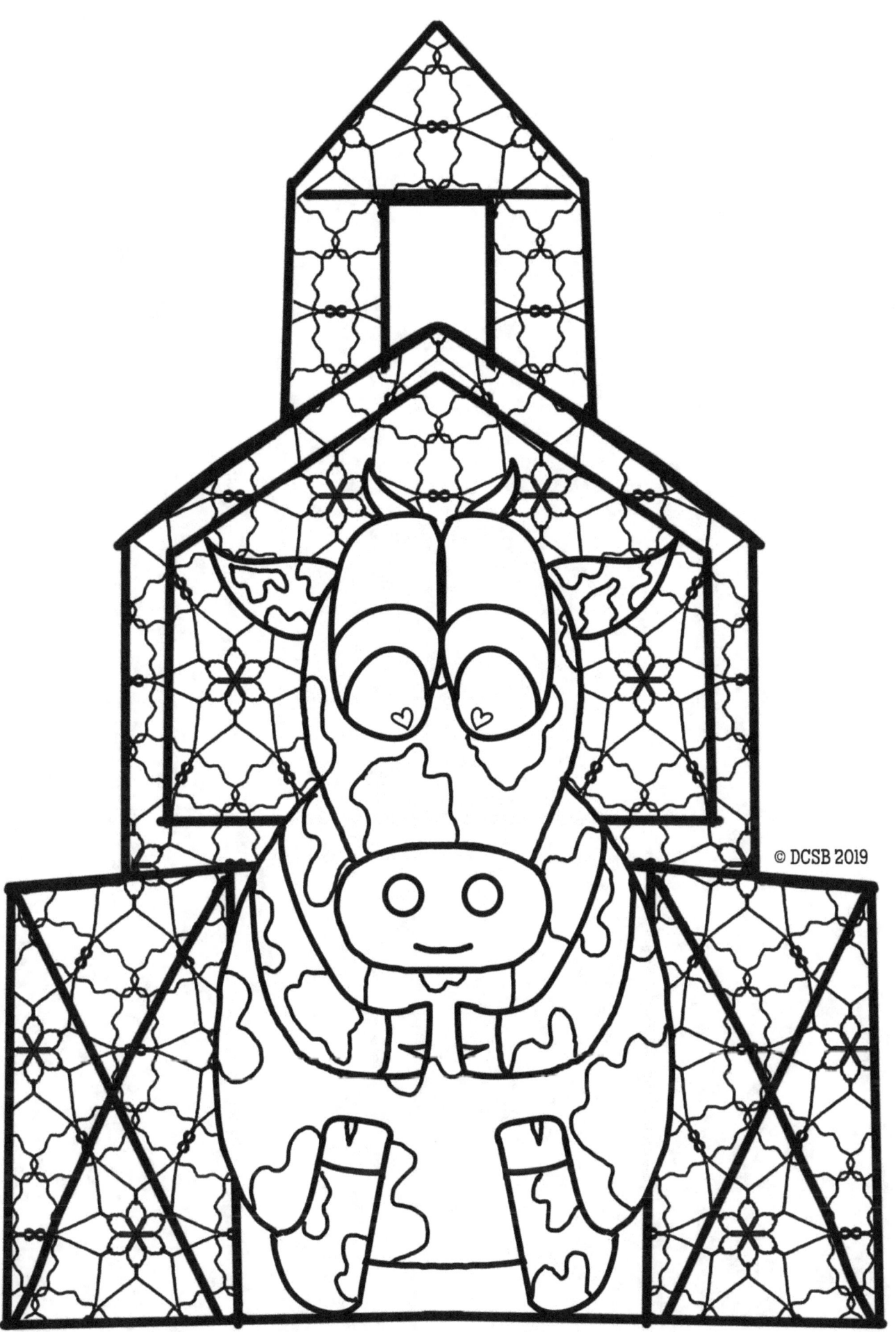

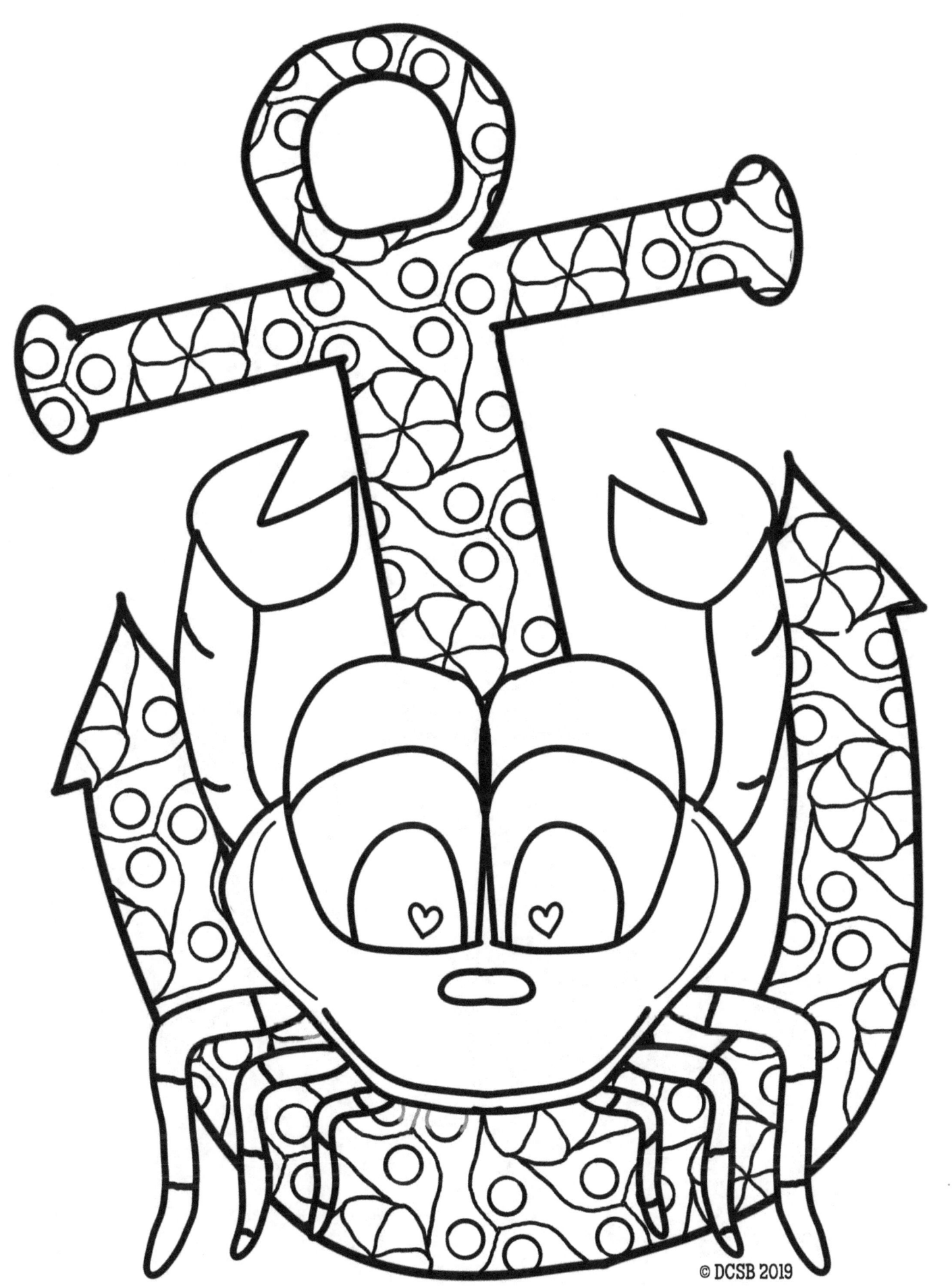

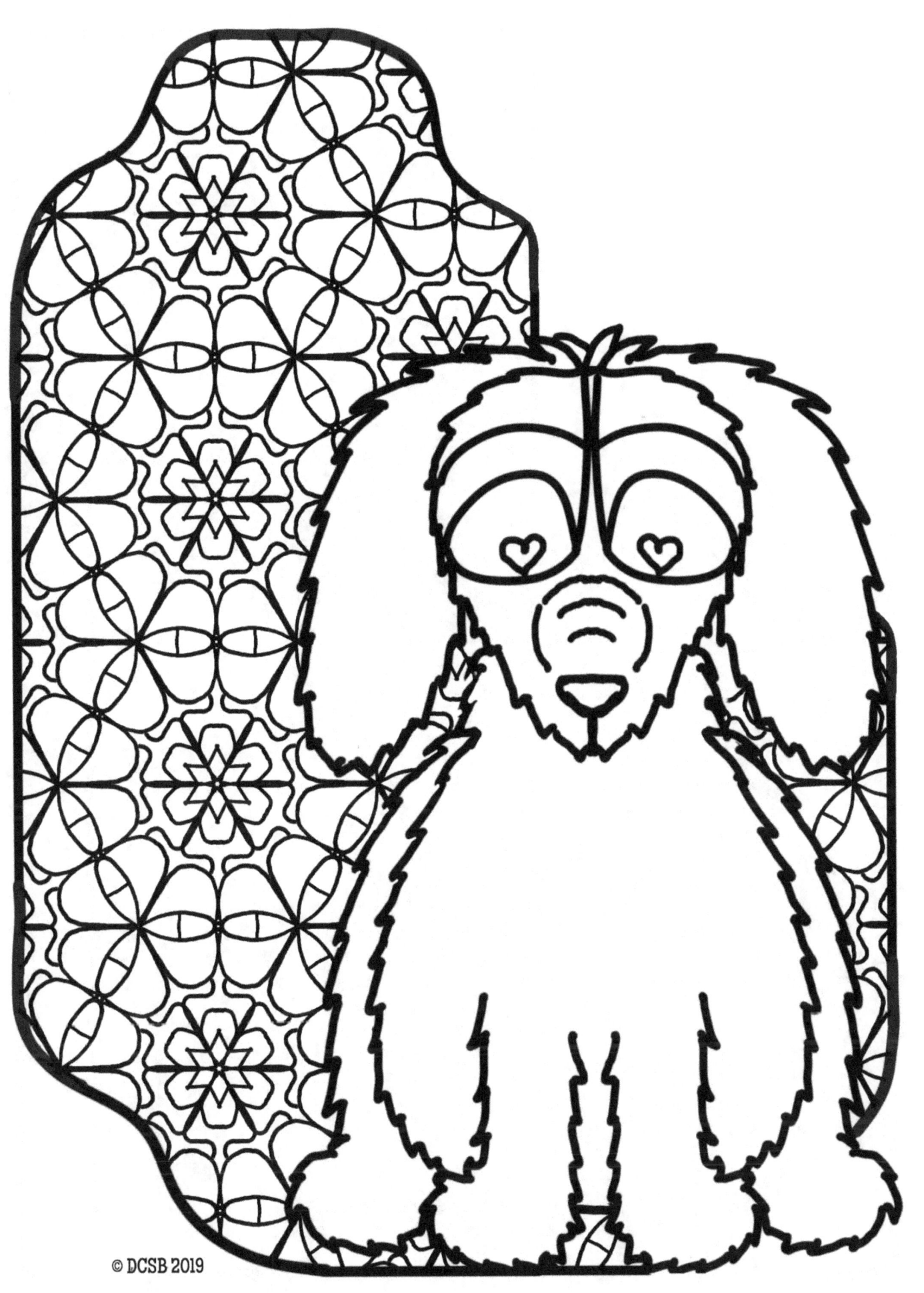

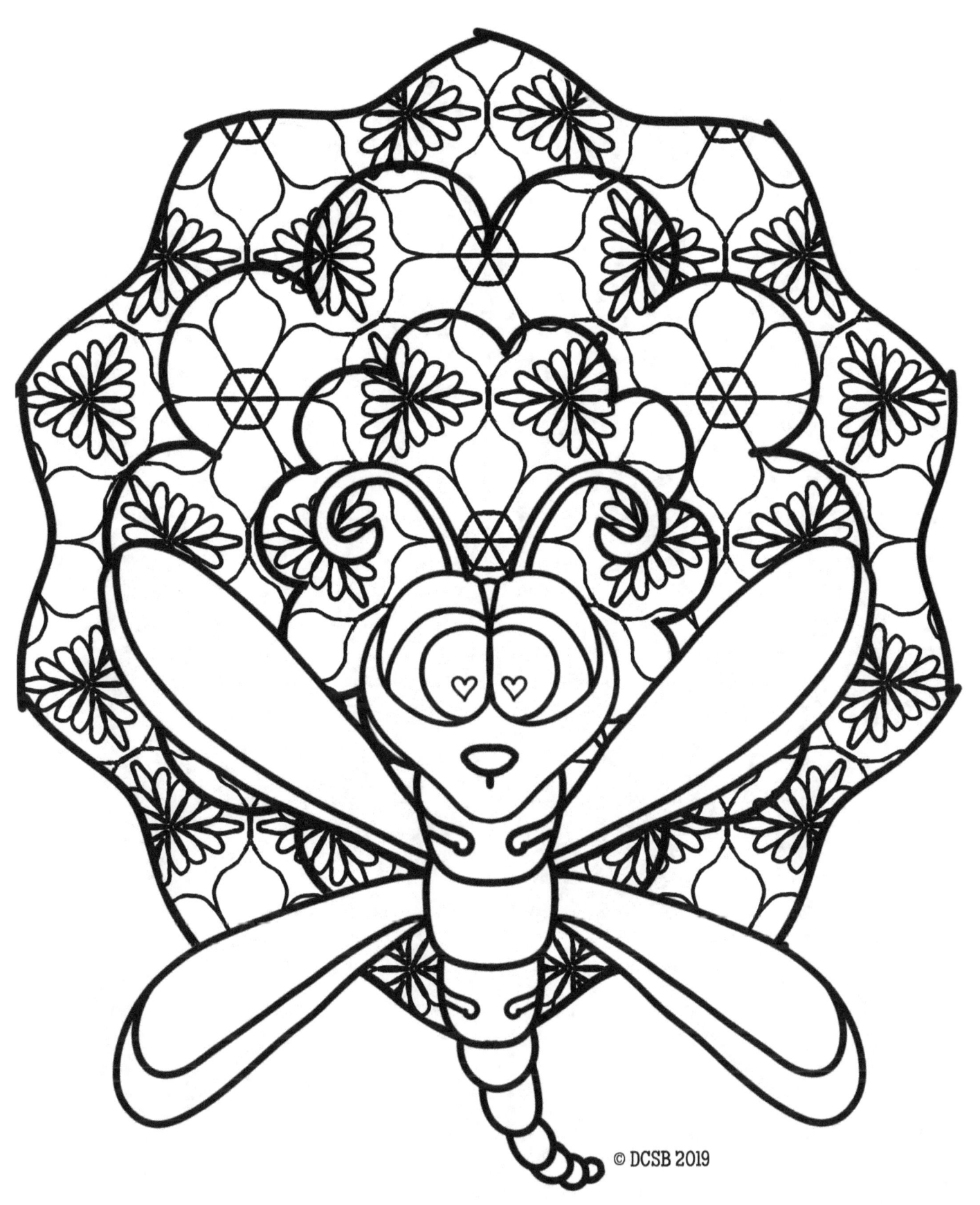

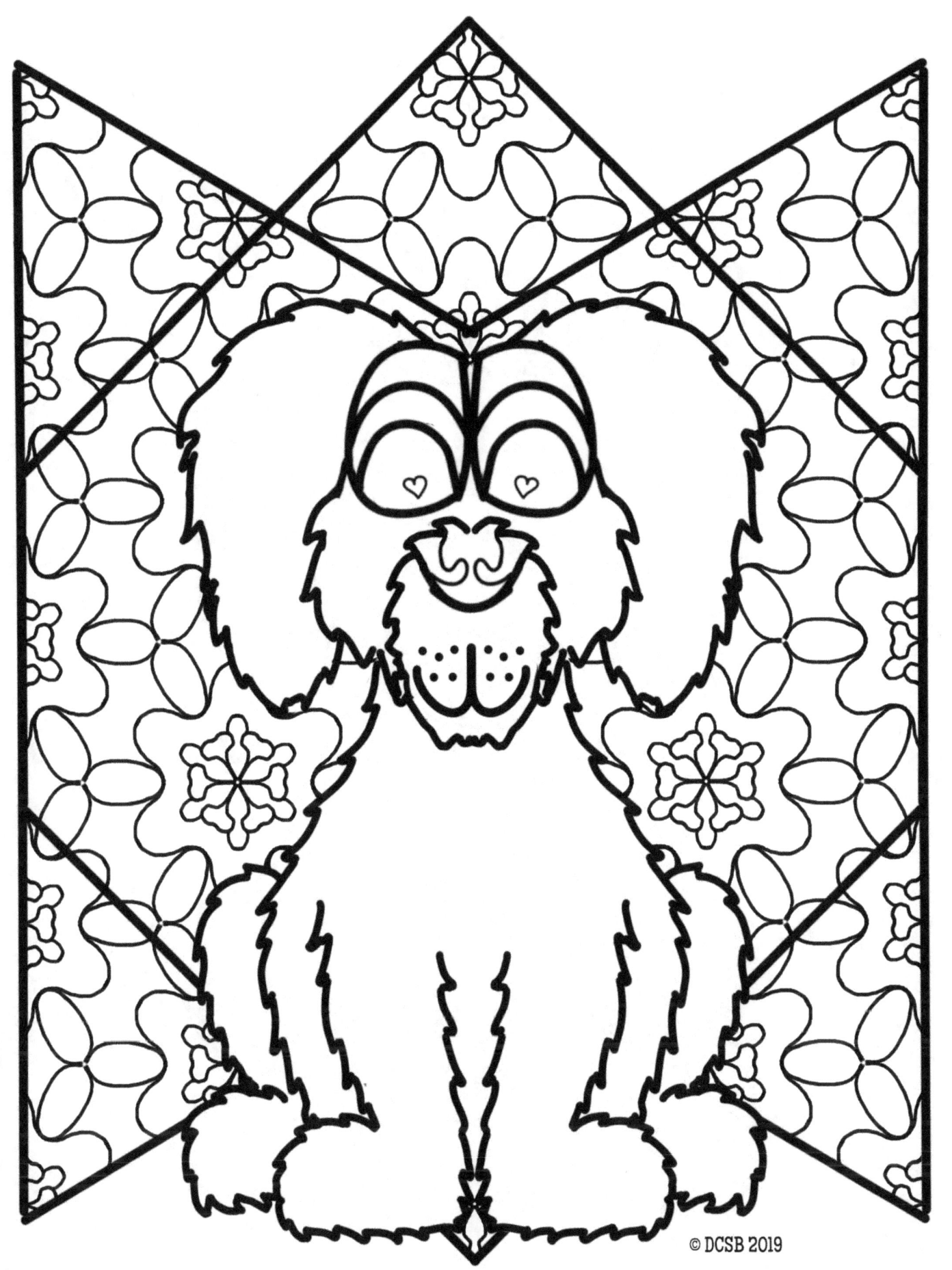

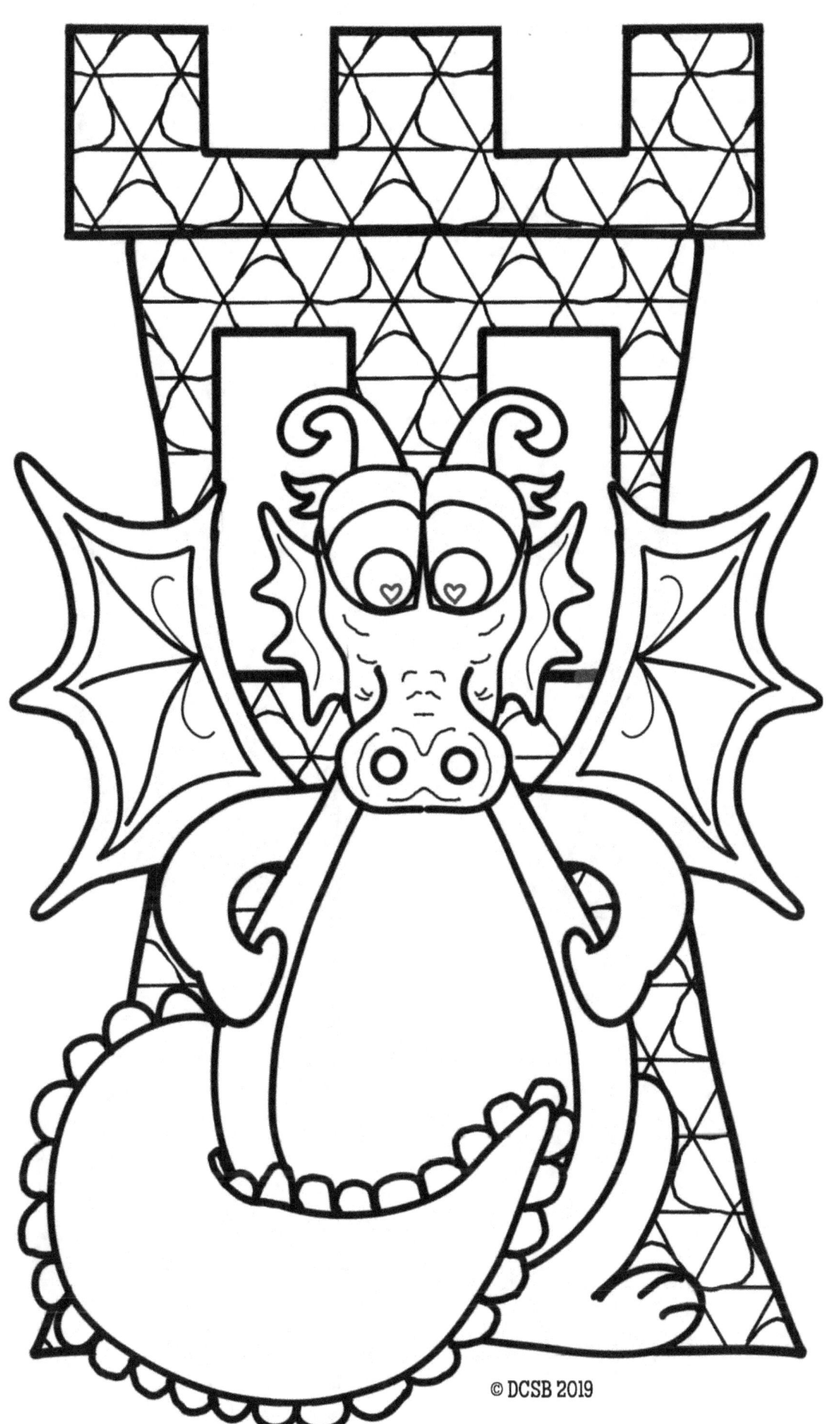

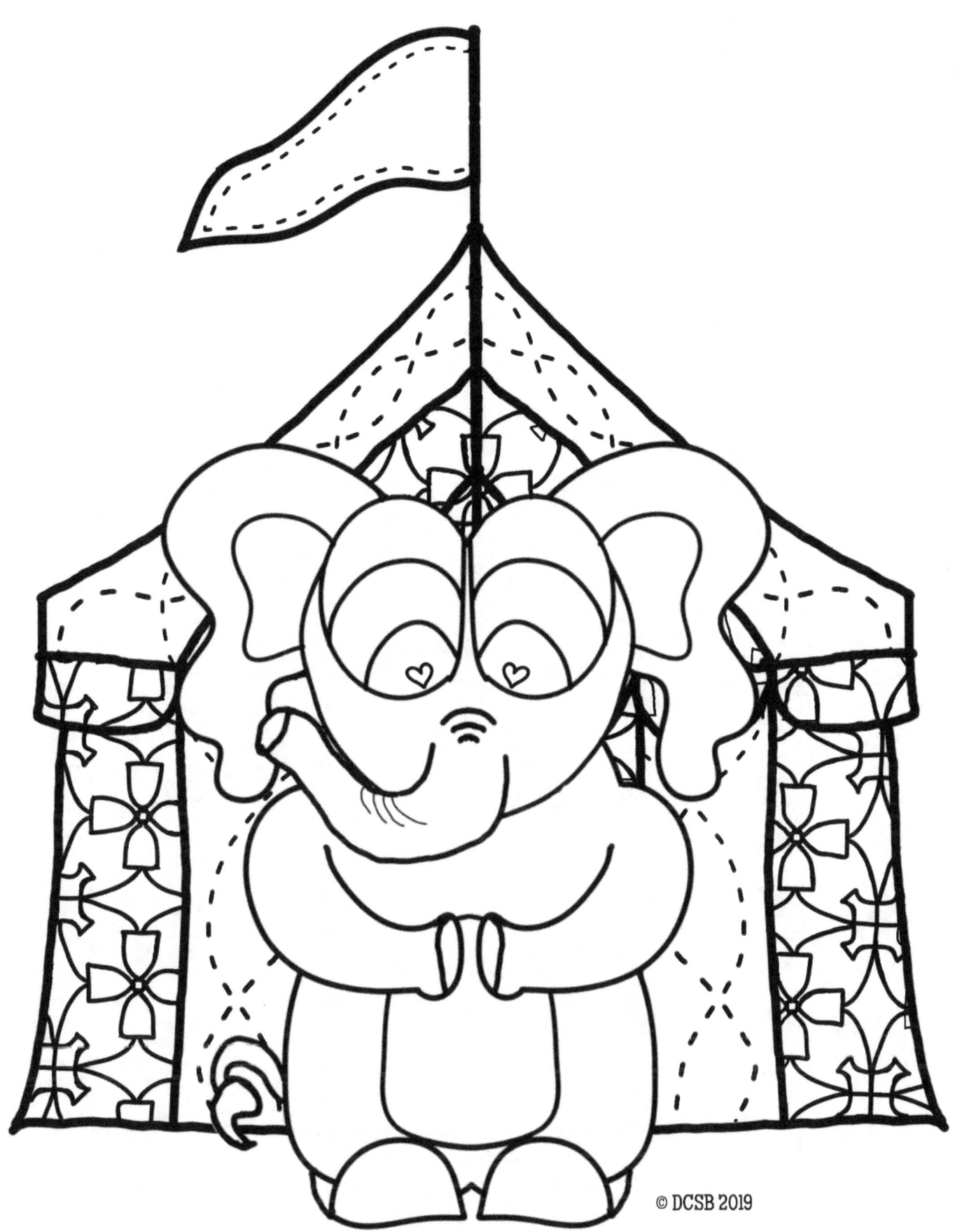

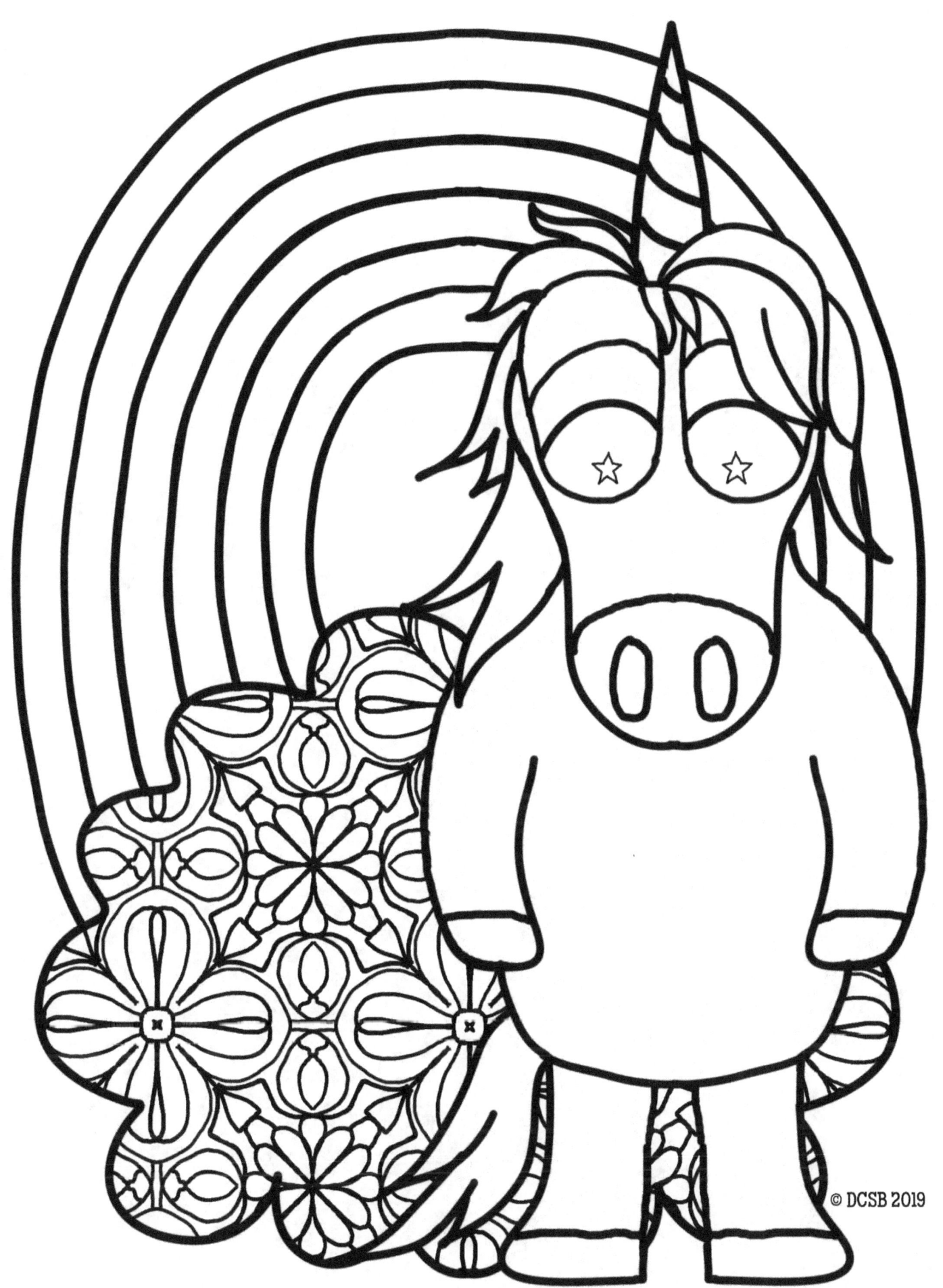

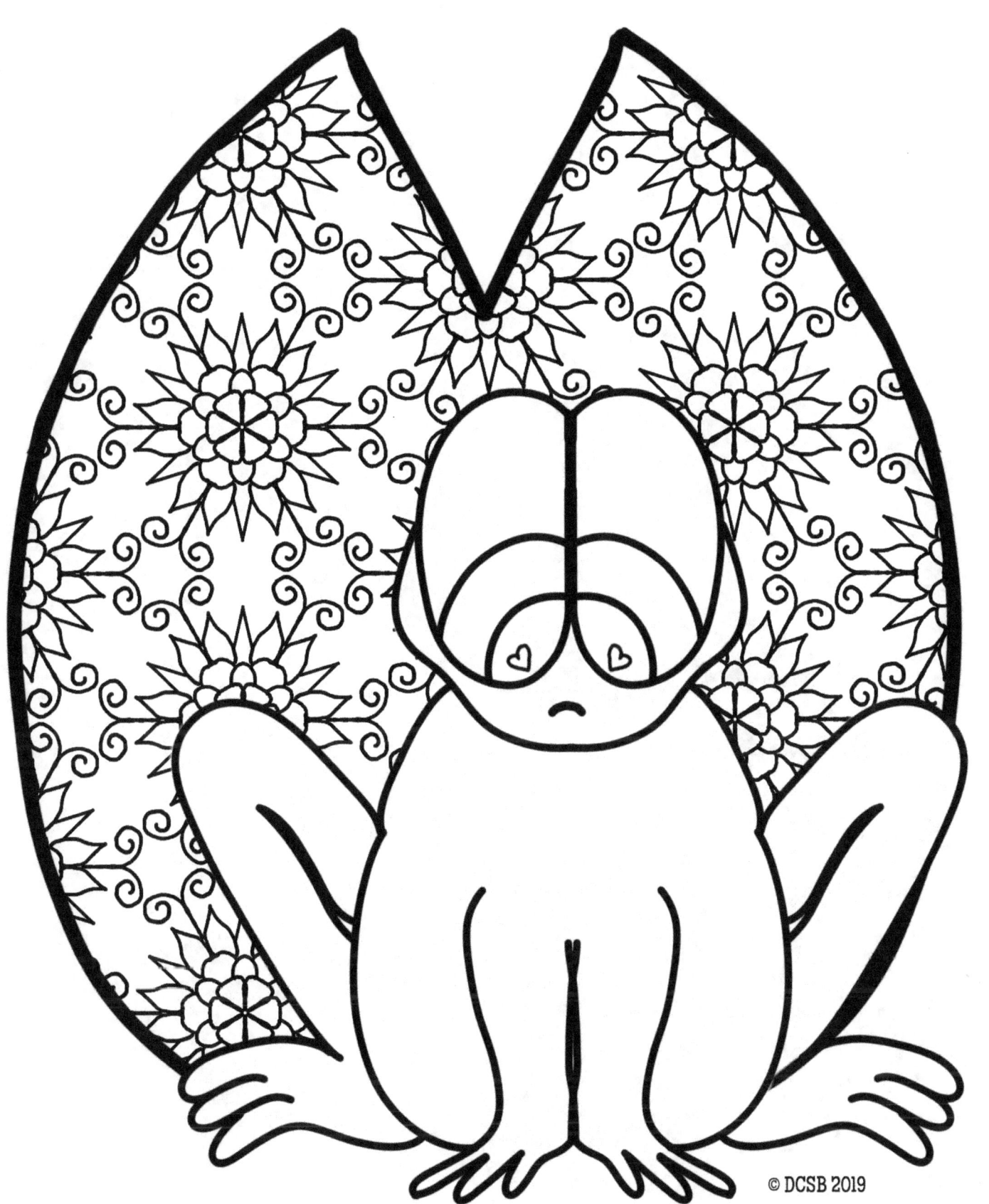

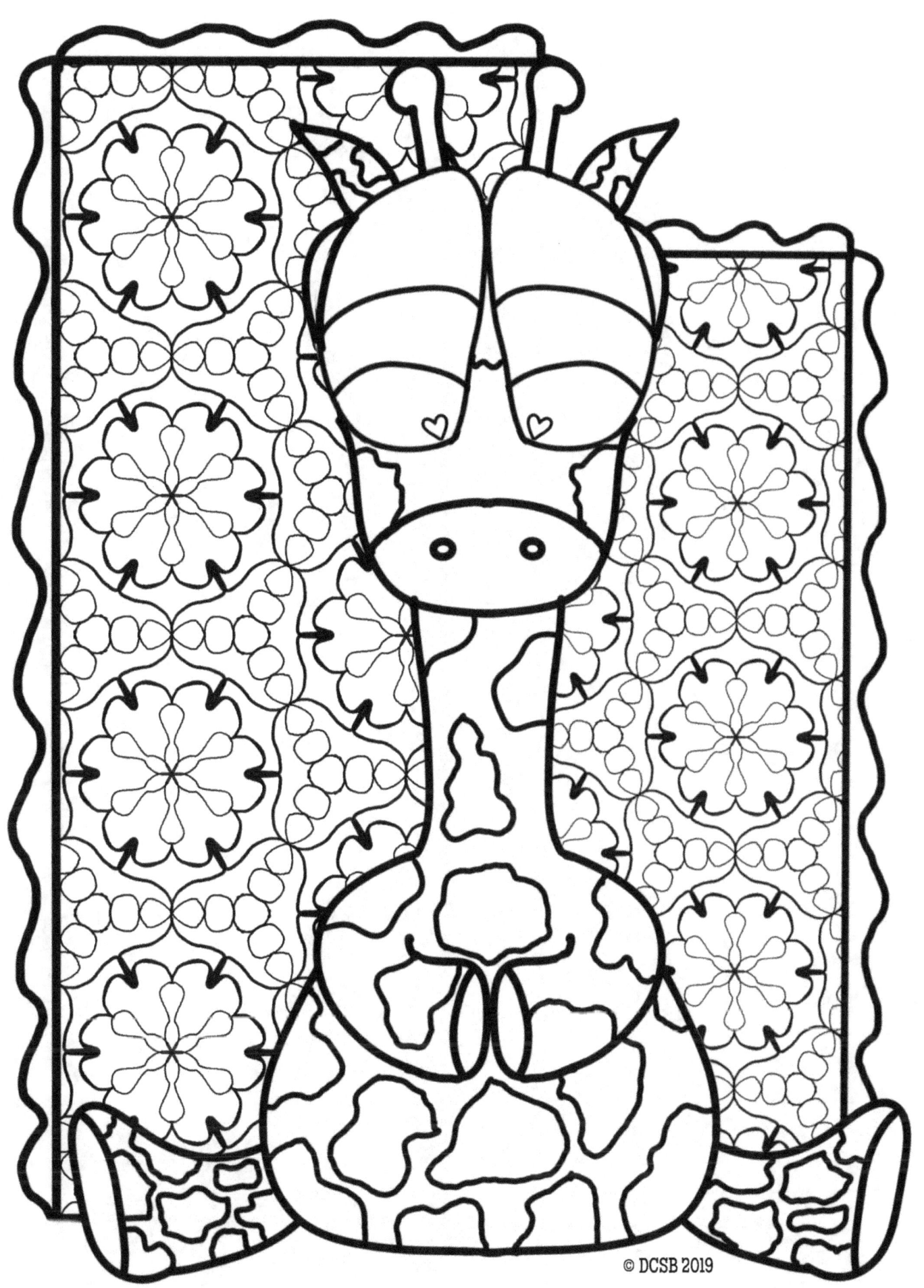

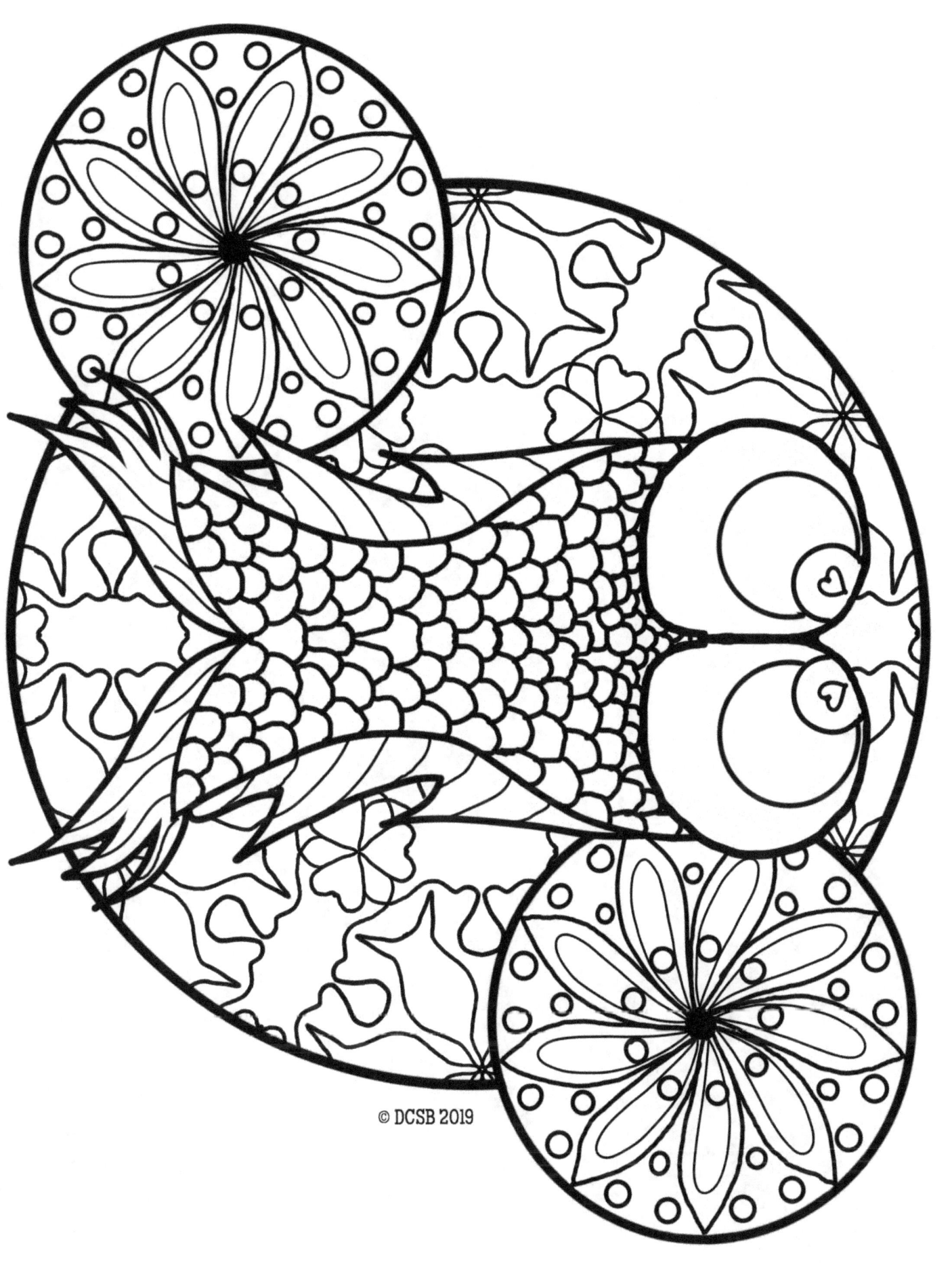

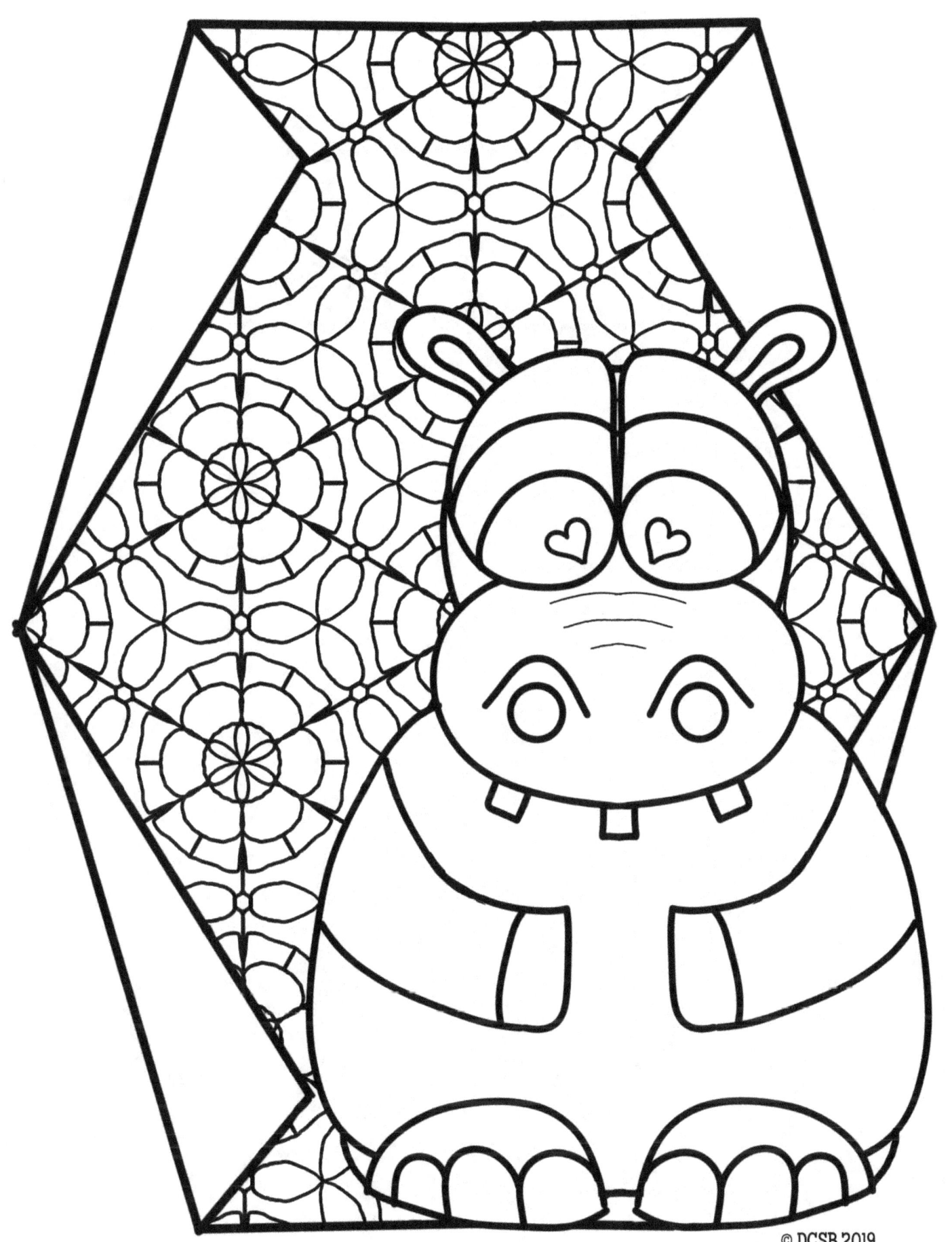

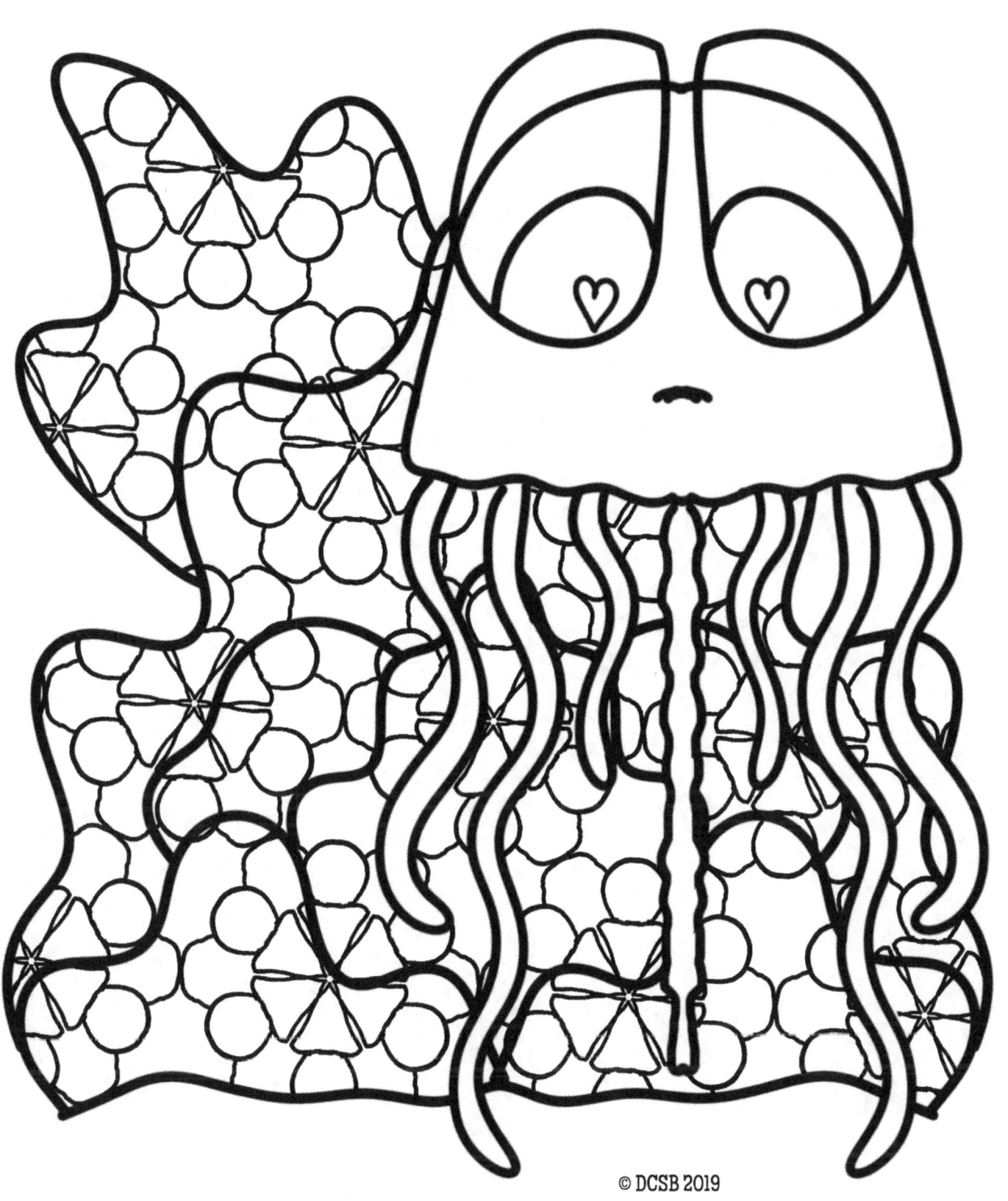

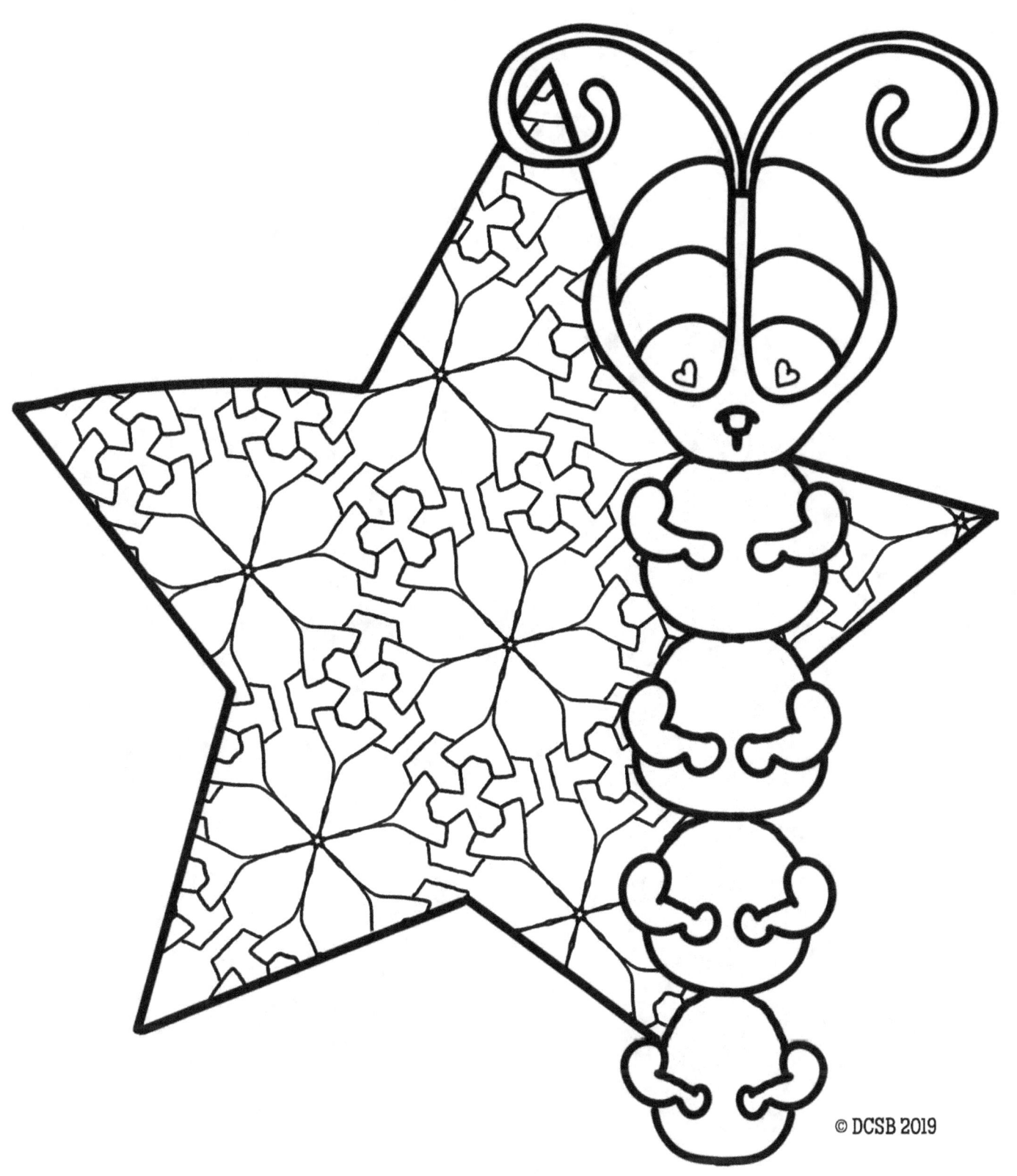

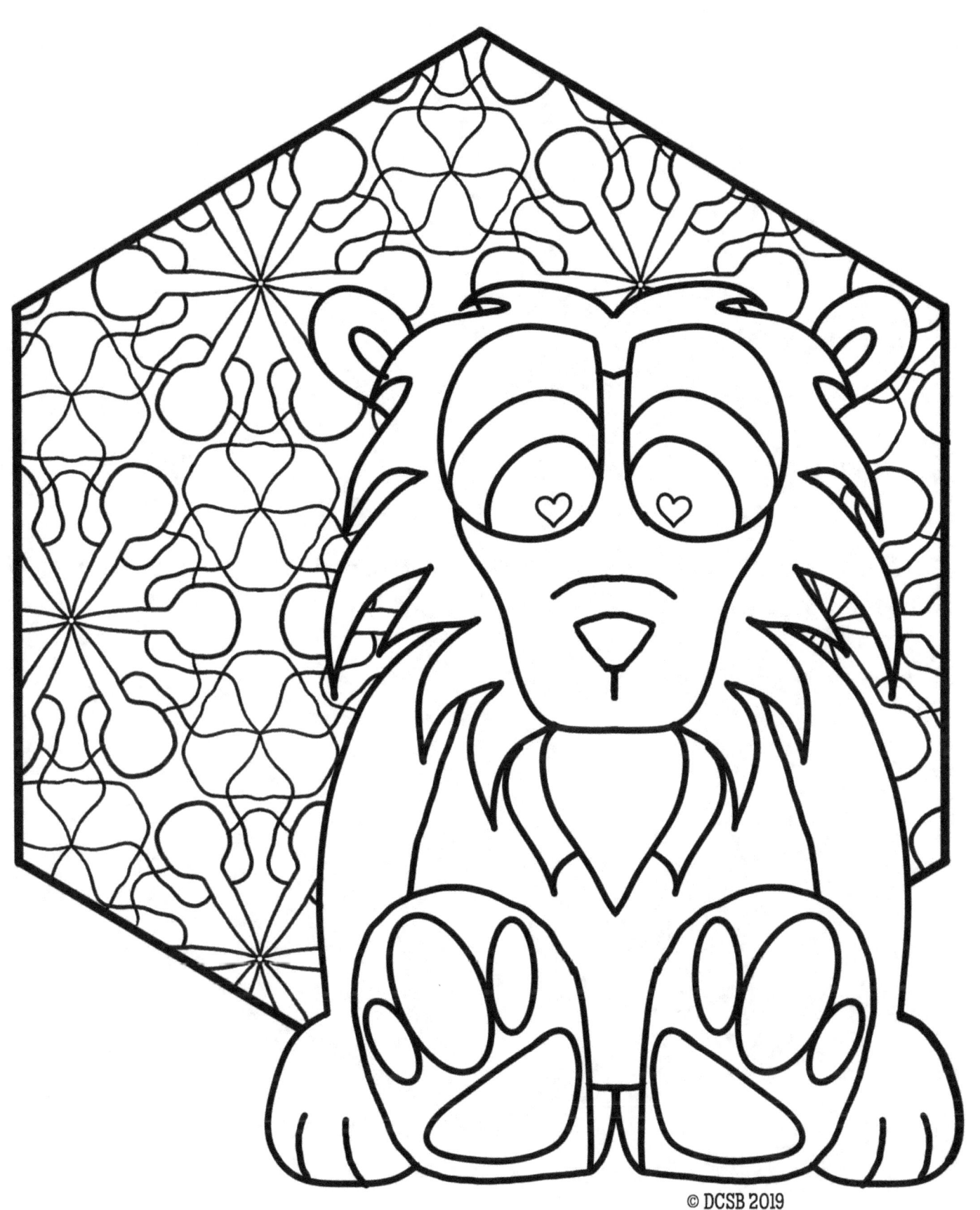

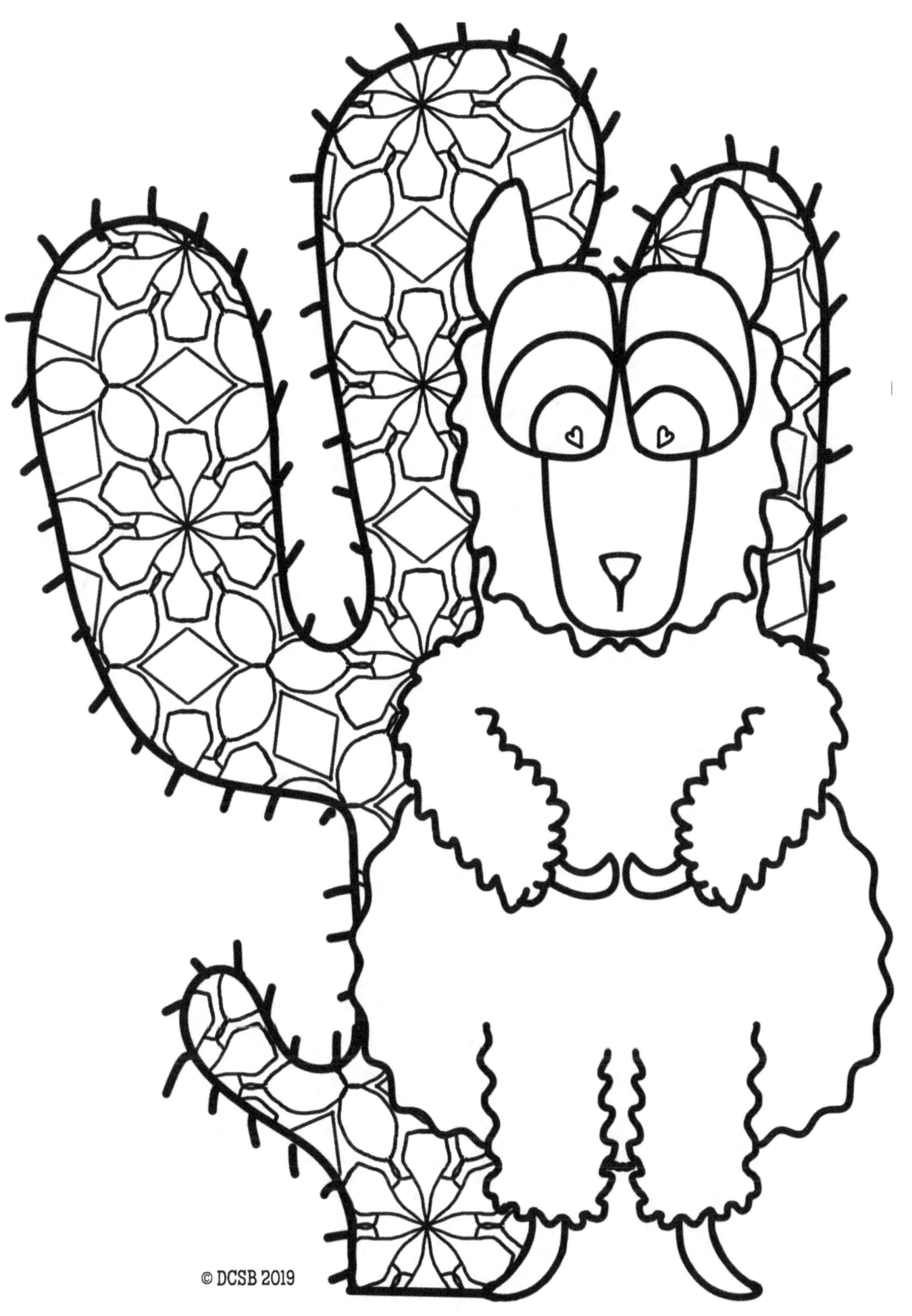

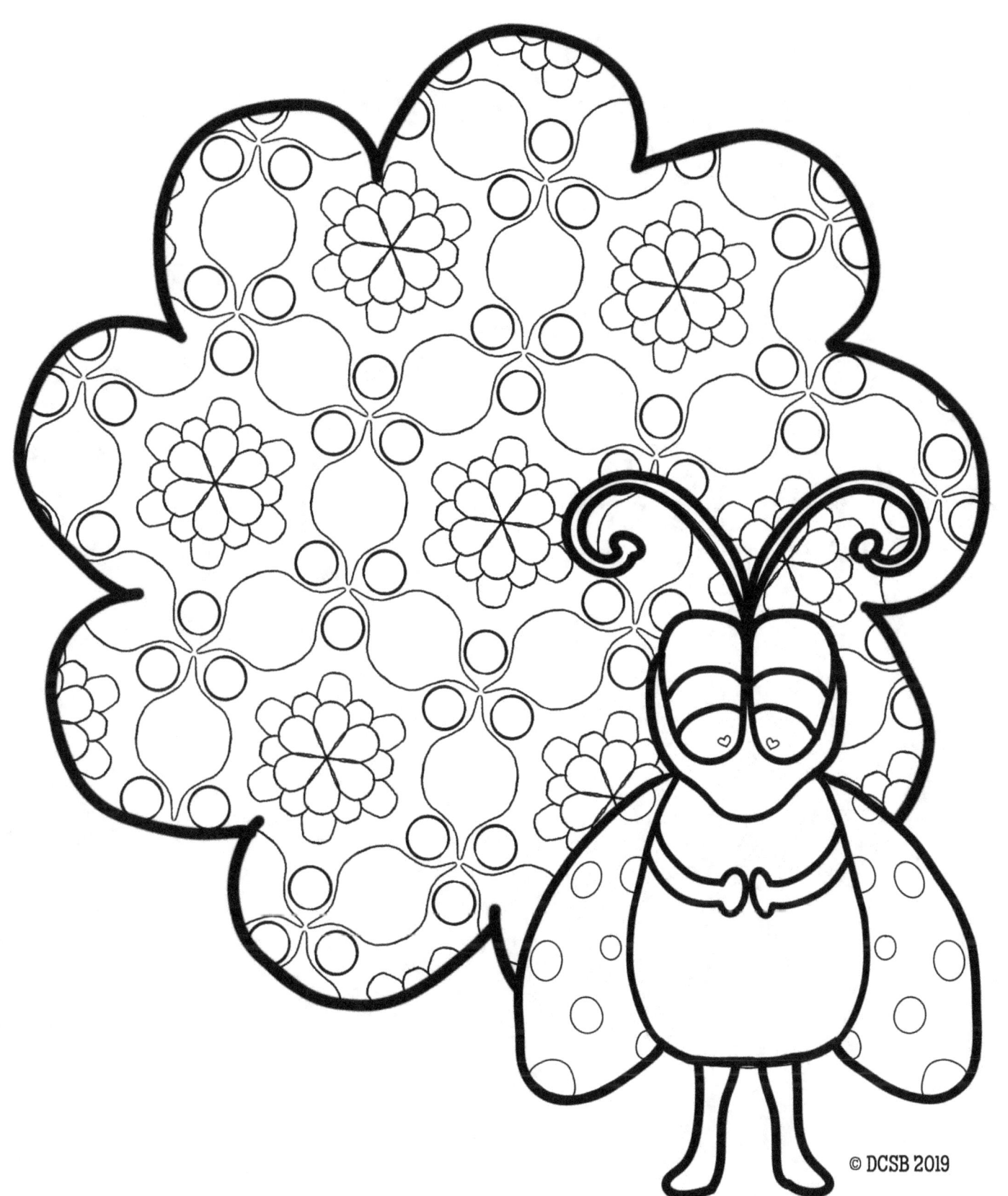

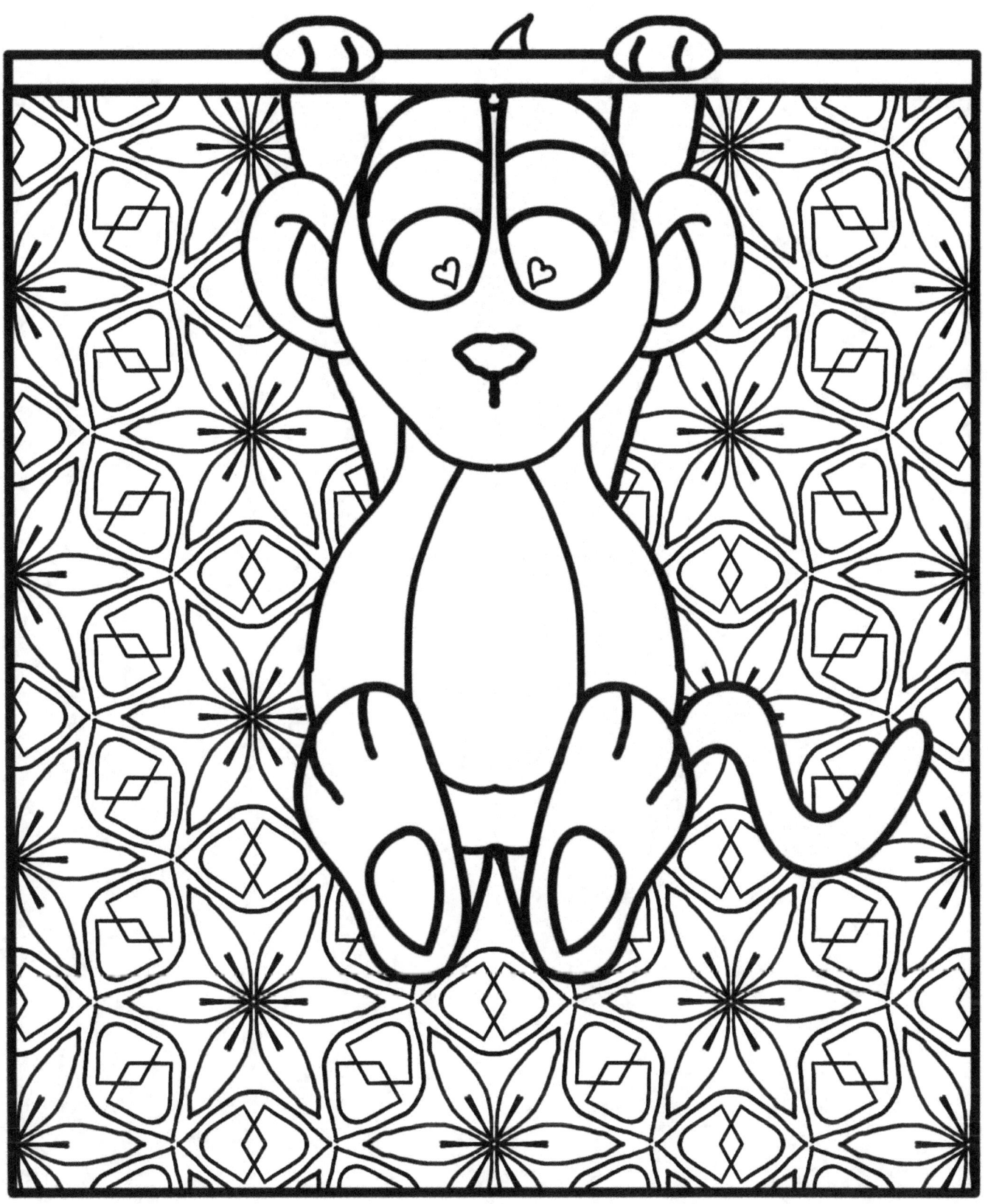

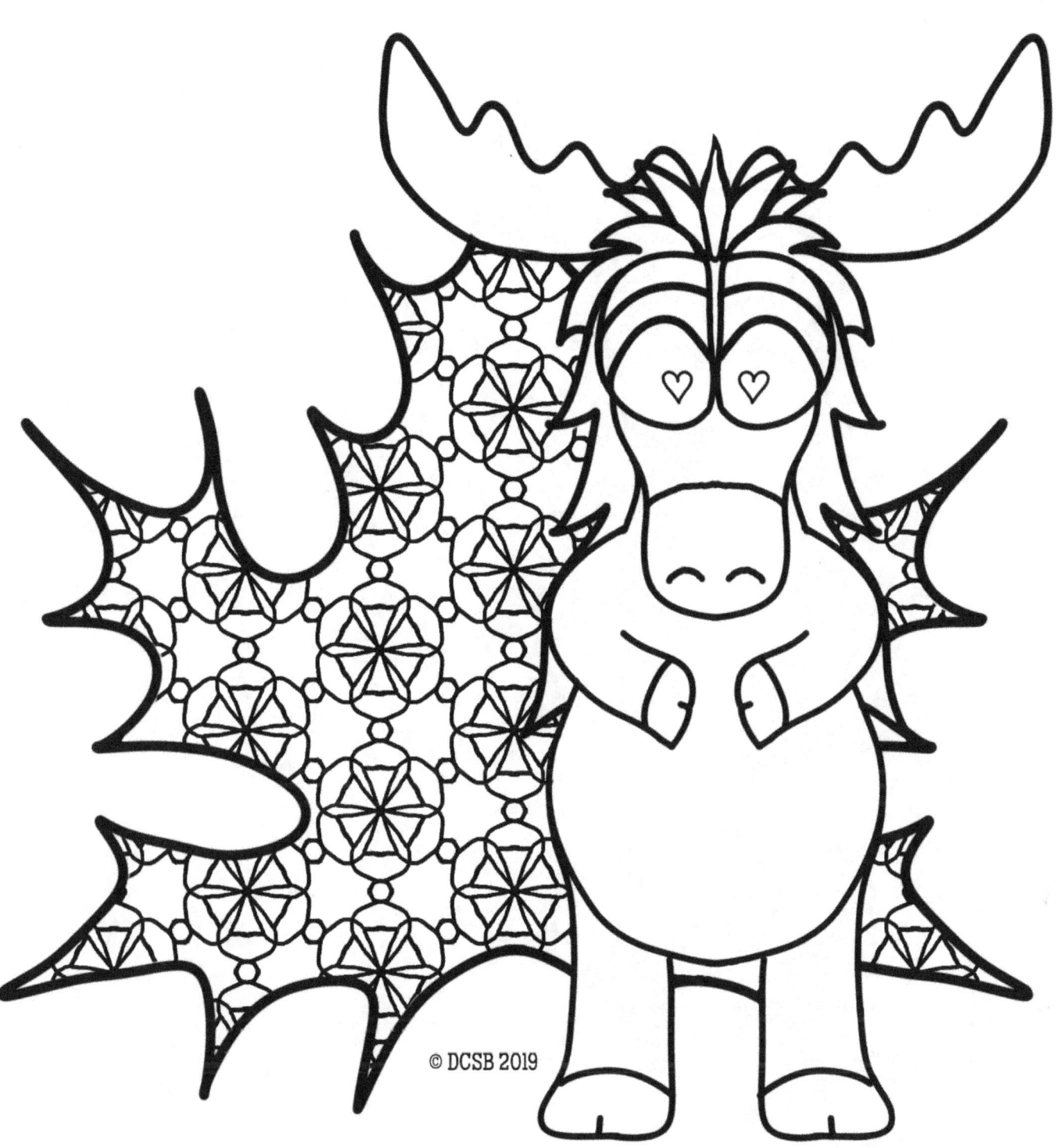

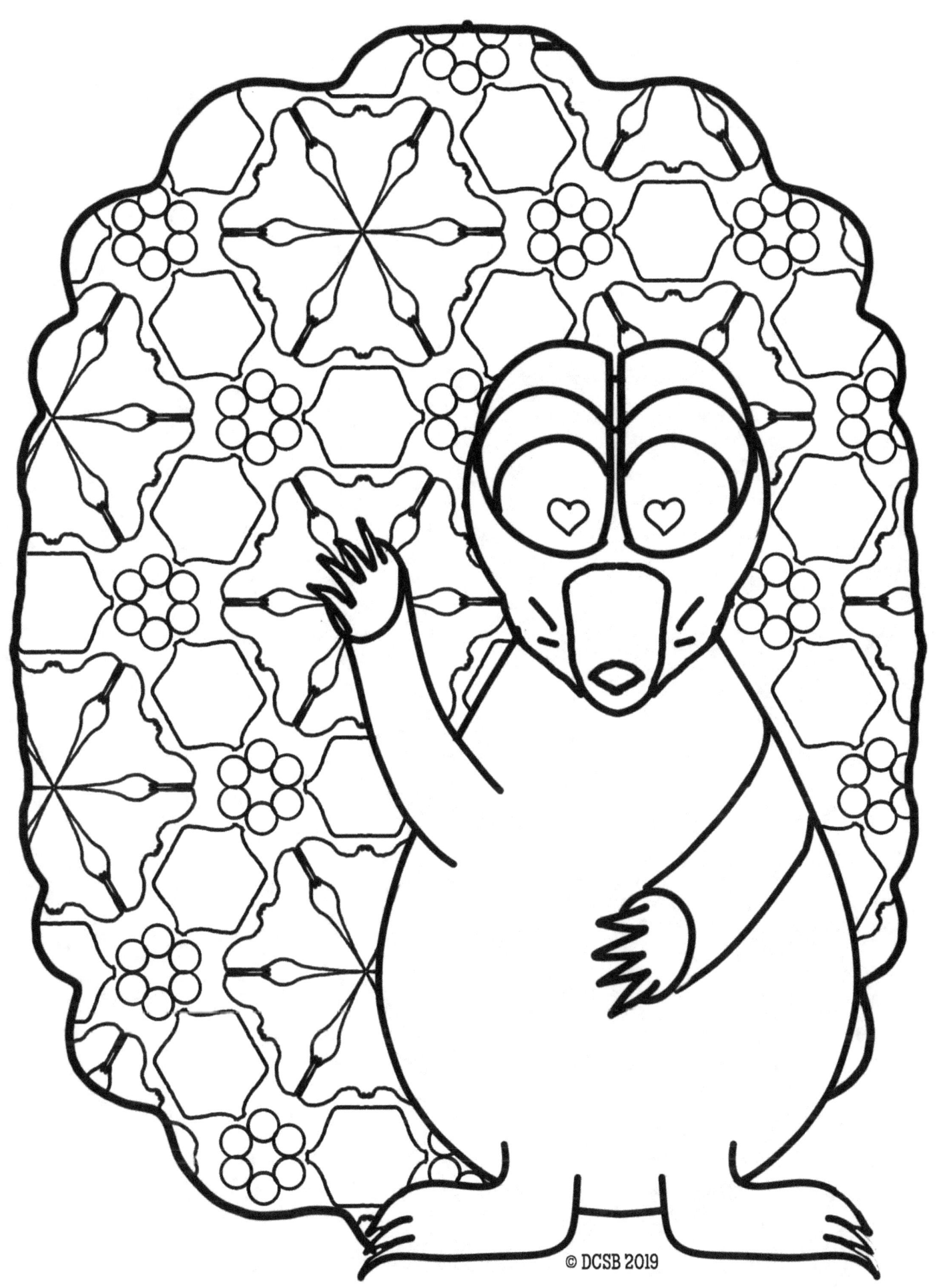

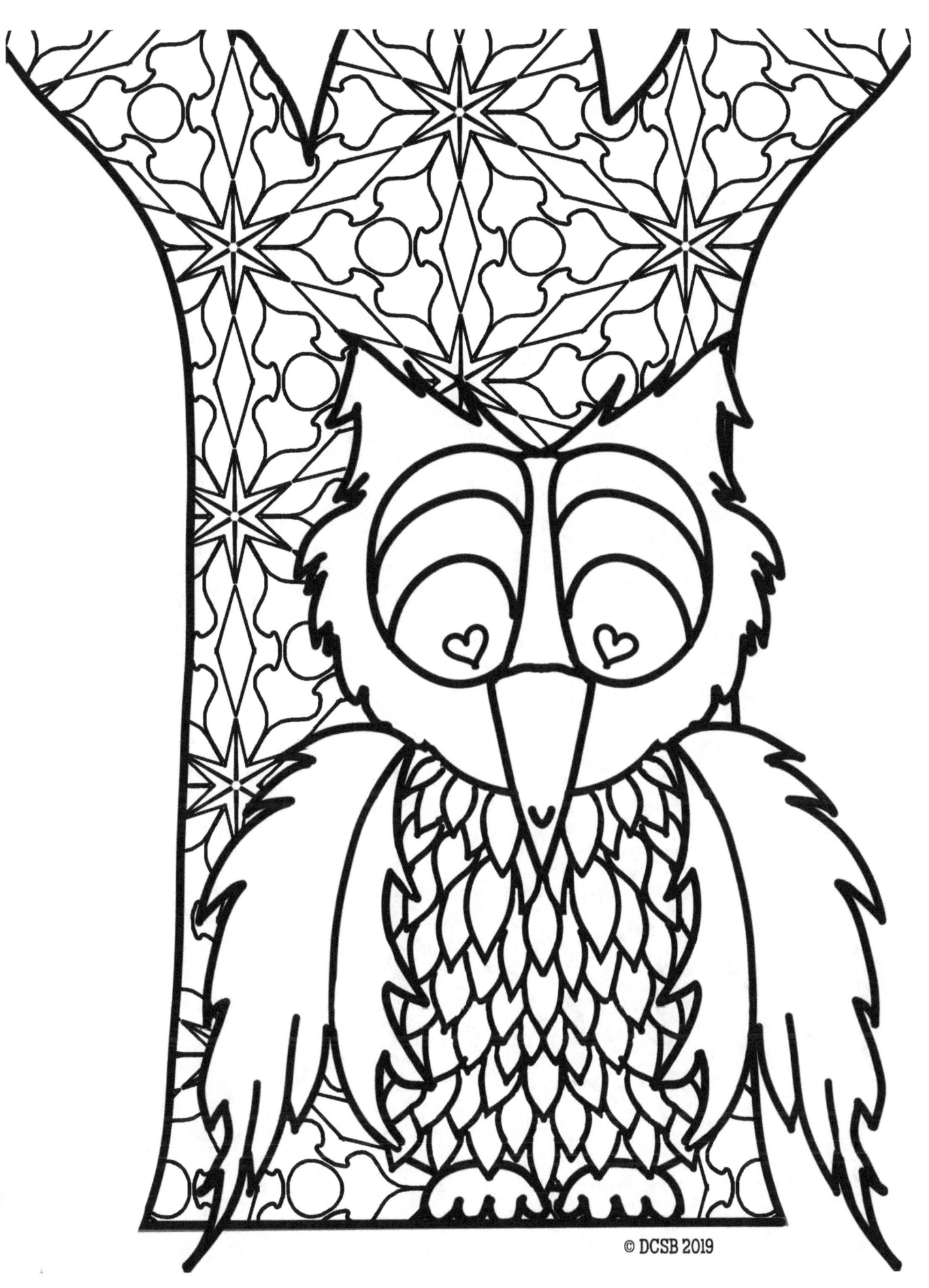

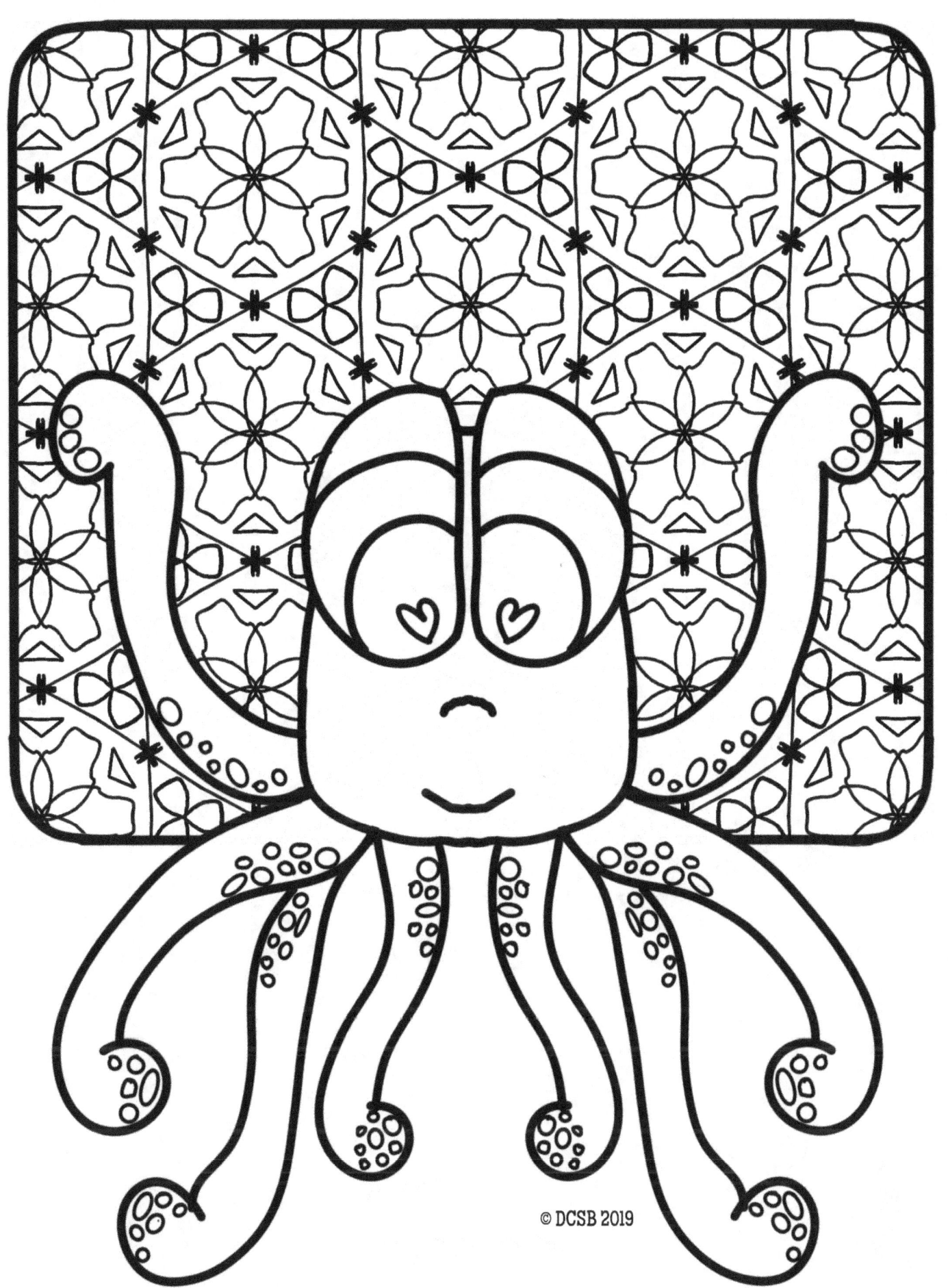

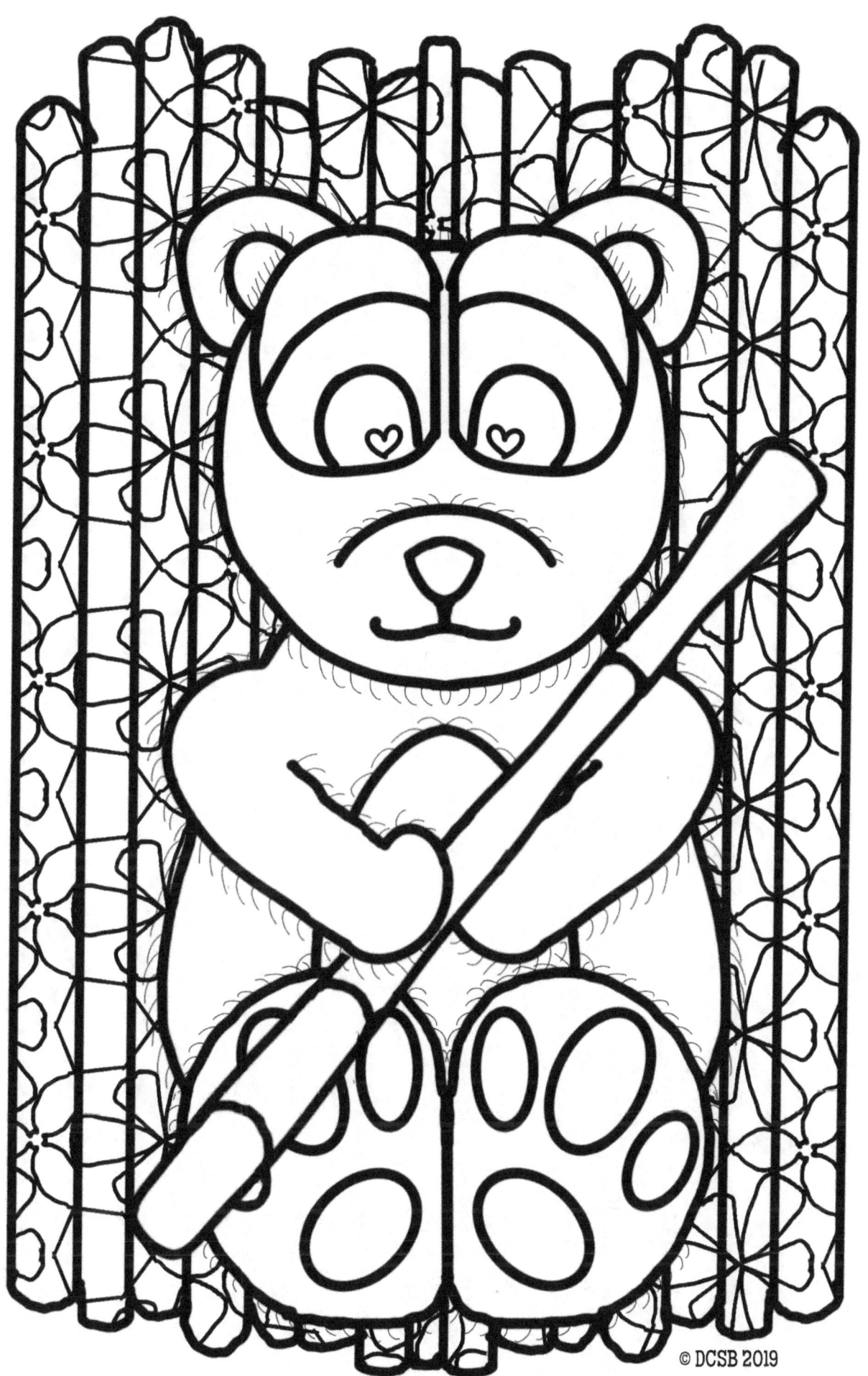

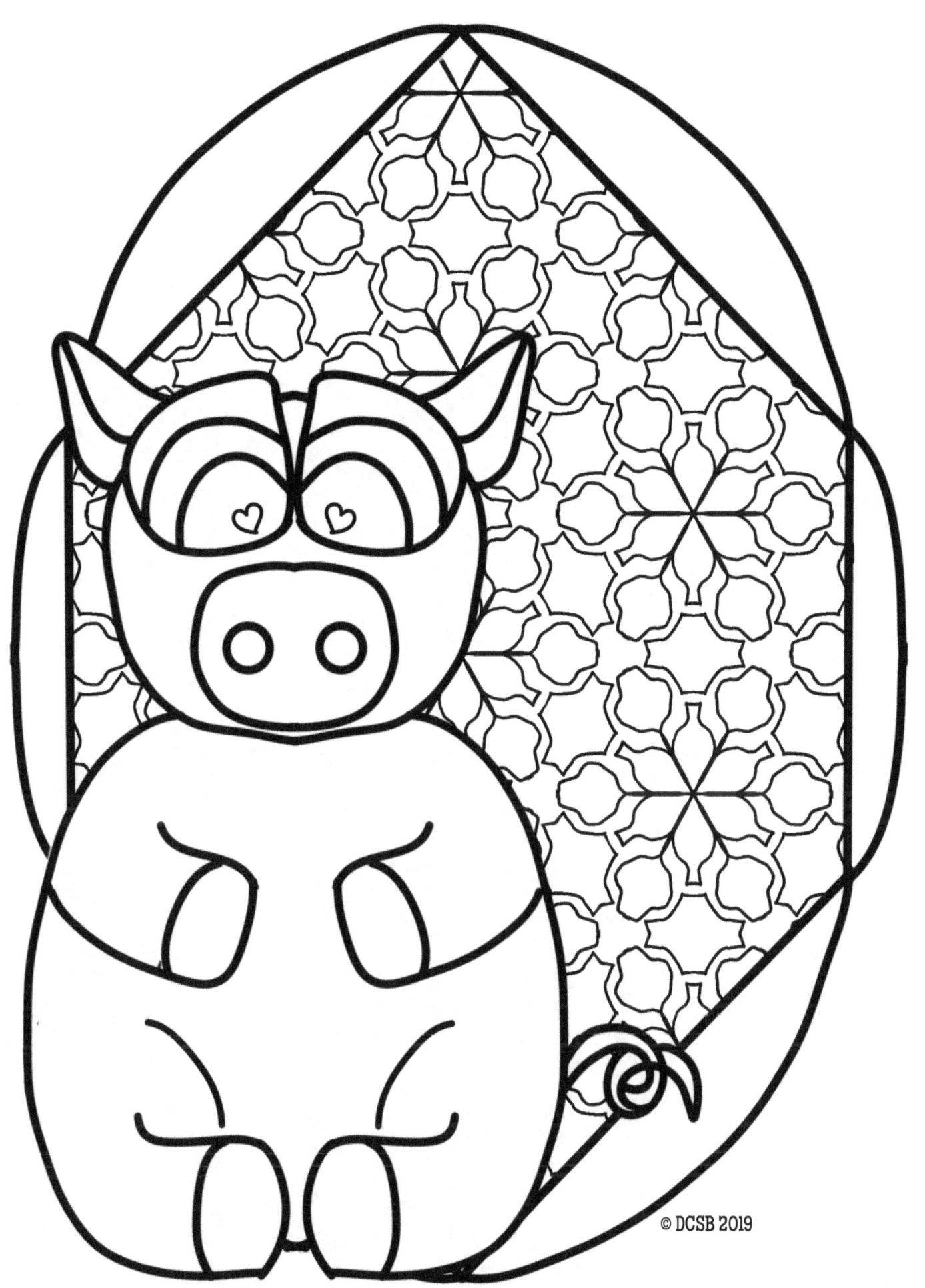

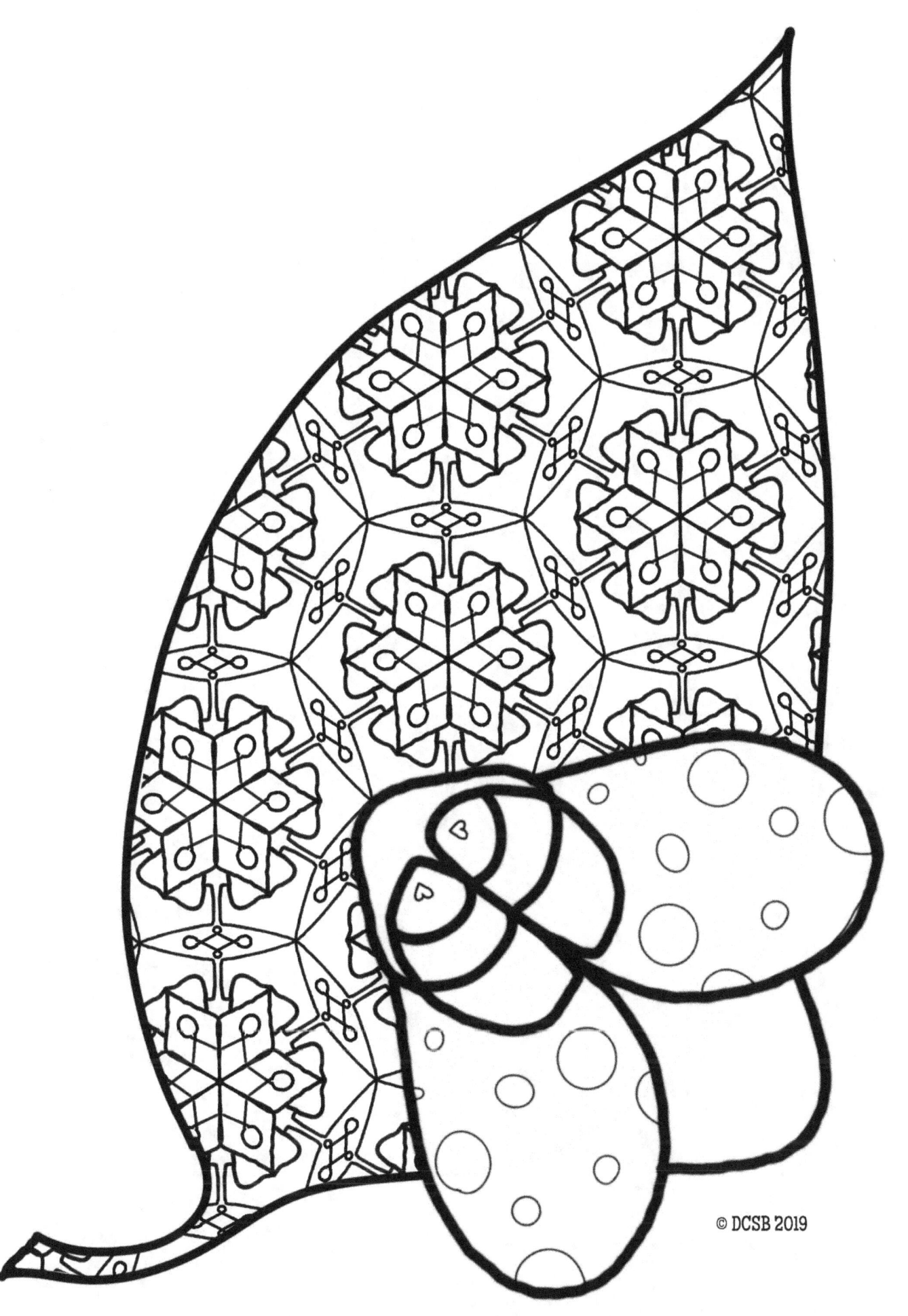

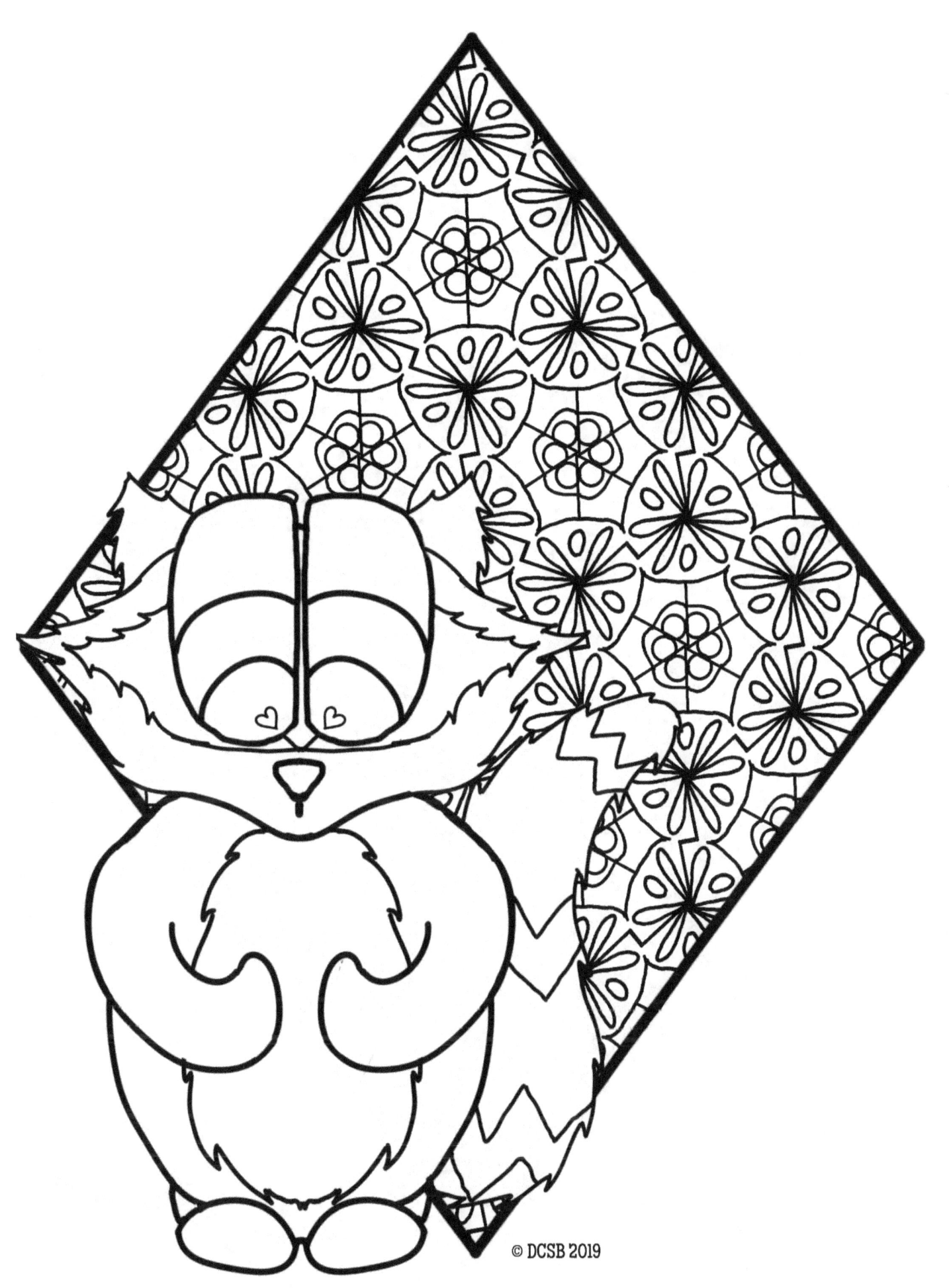

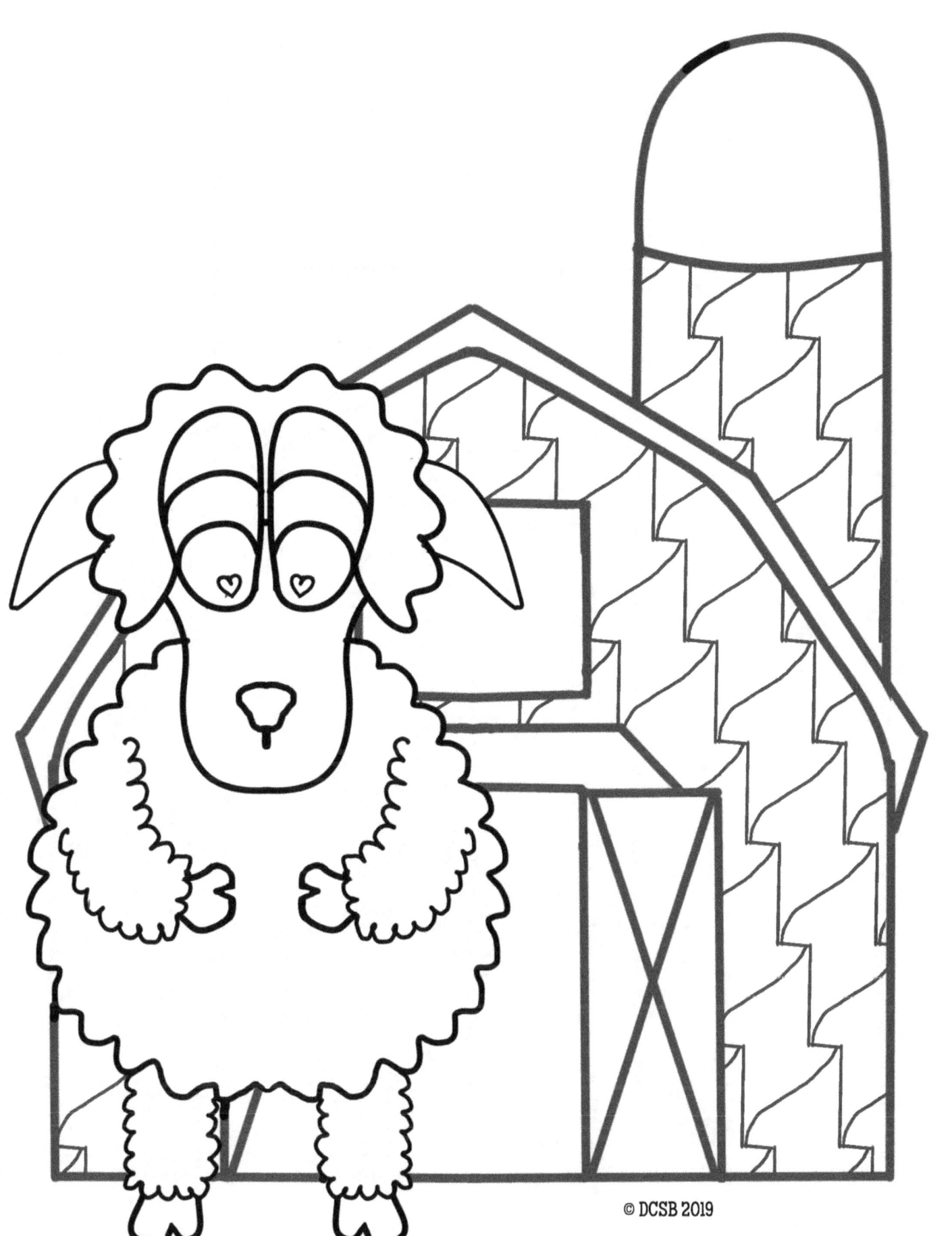

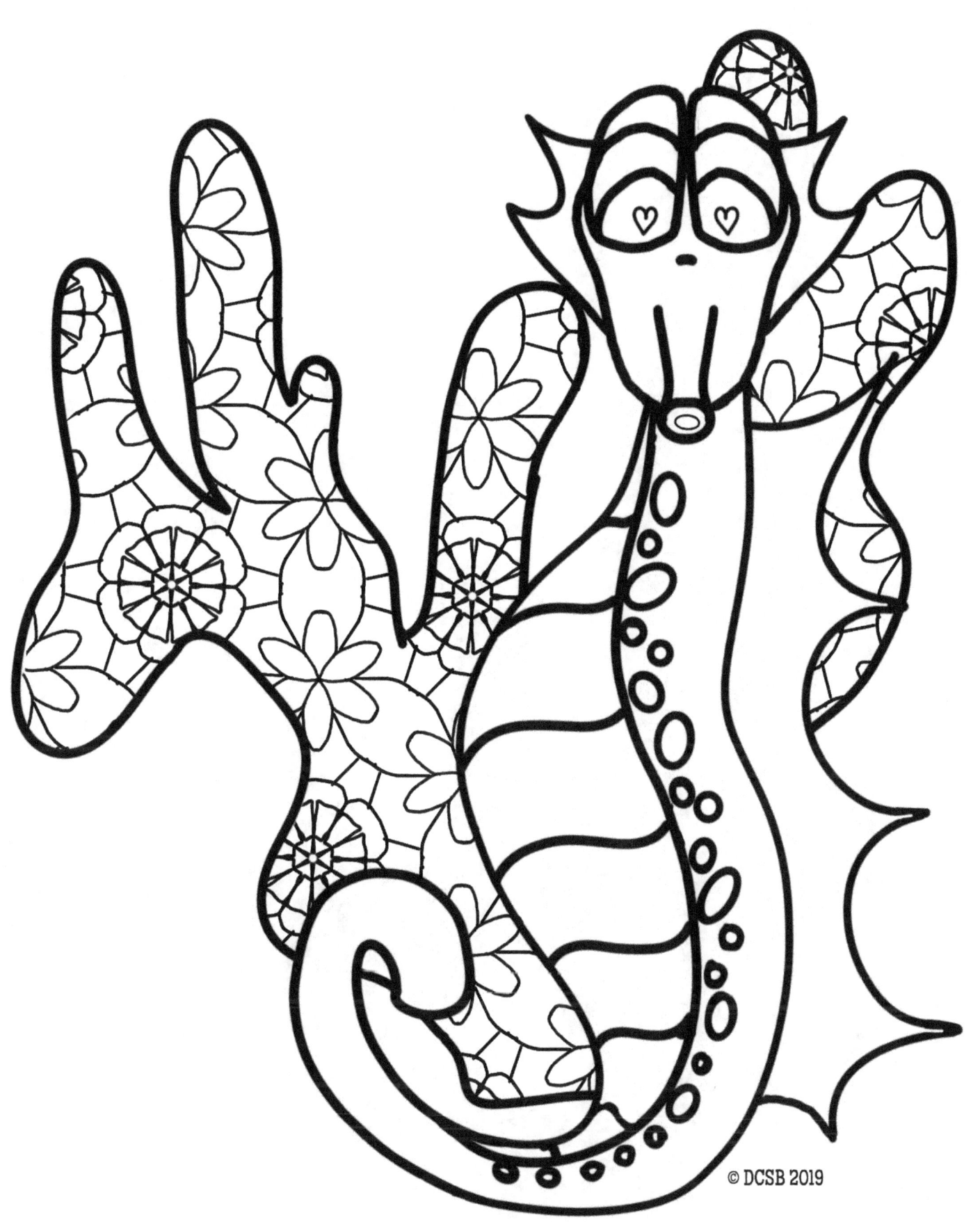

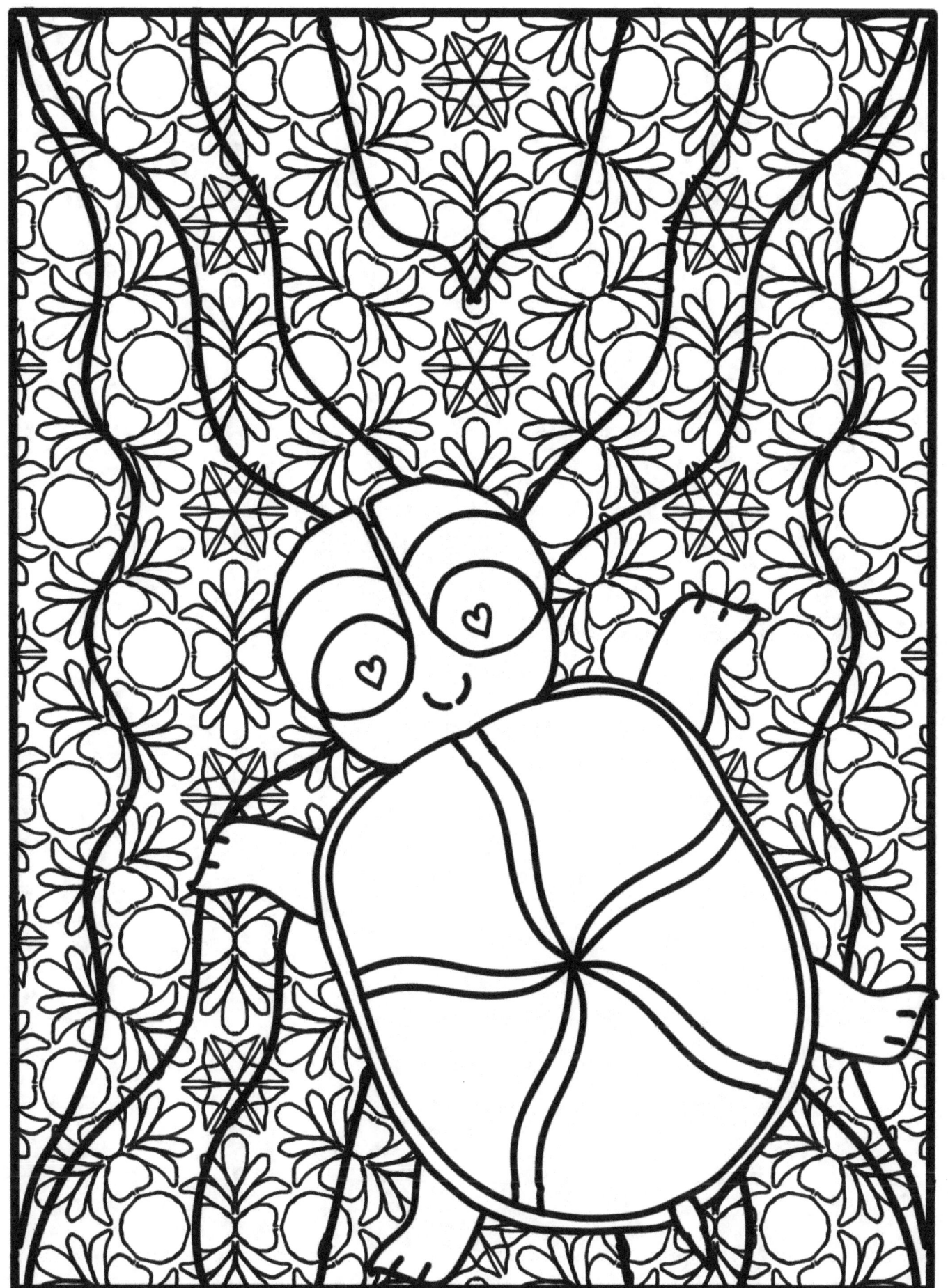

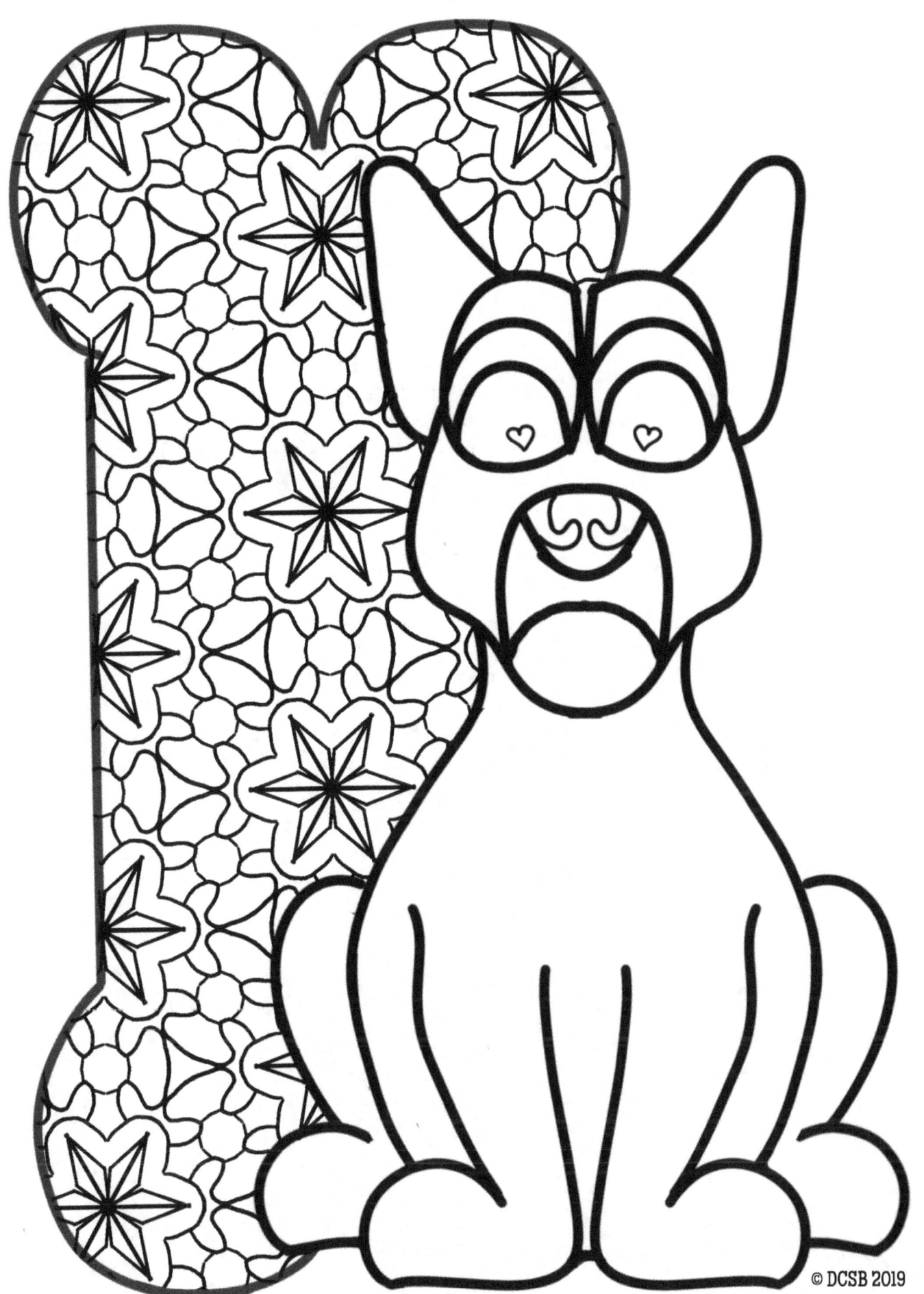

www.ingramcontent.com/pod-product-compliance
Lightning Source LLC
Chambersburg PA
CBHW080819170526
45158CB00009B/2475